THE *Whitney* I KNEW

THE *Whitney* I KNEW

BY
BEBE WINANS

WITH TIMOTHY WILLARD

WORTHY
PUBLISHING

Published by Worthy Publishing, a division of Worthy Media, Inc., 134 Franklin Road, Suite 200, Brentwood, Tennessee 37027.

HELPING PEOPLE EXPERIENCE THE HEART OF GOD

eBook available at www.worthypublishing.com

Audio distributed through Oasis Audio; visit www.oasisaudio.com

Library of Congress Control Number: 2012941808

For foreign and subsidiary rights, contact Riggins International Rights Services, Inc.; www.rigginsrights.com

Published in association with Jan Miller of Dupree Miller Associates

Every effort has been made to secure photo credits for the images in the photo section. However, since many of these were in the author's personal collection, some photographers are currently unknown. To be properly credited on any photo in future printings, please contact Worthy Publishing at www.worthypublishing.com

ISBN: 978-1-61795-084-1 (hardcover)

Cover Design: Chris Tobias, Tobias Design
Cover Photo: Michaelangelo de Battista
Interior Design and Typesetting: Kimberly Sagmiller, FudgeCreative

Printed in the United States of America
12 13 14 15 16 17 LBM 8 7 6 5 4 3 2 1

I dedicate this book to the loving memory of a wonderful
daughter, sister, mother, niece, cousin, and true friend.
Whitney, your life down here, though a mere forty-eight years,
will never be forgotten. You have left an everlasting mark
on a world in search of the simple beauties from above—
and your voice was one of those.

As time goes on, when I hear your songs soaring across
the airwaves, I'm sure the pain will turn to laughter because
that's who you were—a gift from God who loved to laugh.
We both knew that there was no better medicine for the soul
than laughter. Some questions will go unanswered, I'm sure,
while some answers I'll find in the dark of the night,
right when I'm not looking.

Contents

"It is my prayer and that of our family's that you . . .
remember [Whitney] with the love that she gave
everyone, no matter what [was] going on."

❖

WHITNEY'S SISTER-IN-LAW, PAT HOUSTON
Speaking at the funeral

INTRODUCTION:

The Ones We Love

You spend enough time with someone, and there will be moments
when you catch glimpses of their true selves.

BeBe

❧

Oh, she was a different bird.

Cissy Houston, Whitney's mama, spoke through her caring
smile when I told her I was writing a book about the Whitney
I knew. "I'm glad you're remembering her like you do, BeBe. They
didn't know her. They think they knew her. You knew her."

But Cissy knew her most of all. That's what moms do. They *know*
you—everything about you.

Cissy went on to tell me how her day that day was particularly
hard—one of the hardest. How the sorrow can hit you when you
least expect it. She wept most of the day. I told her that I was plan-
ning on attending church with her on Easter Sunday (2012). She was
elated.

As we talked, I was able to make her laugh a little. The conversa-
tion took on a sweet tone—a comforting feel.

I find that love is an action word. Knowing how much time she
and Whitney spent together on holidays like Easter, I wasn't trying
to offer a substitute. I knew full well that nothing and no one could

replace the experience of her sweet daughter attending church with her. But the bond between our families stepped in when Whitney died.

Loss and grief don't need words; they need tender action—a body to sit next to, a shoulder to lean on, a presence to keep the loneliness at bay.

You spend enough time with someone, and there will be moments when you catch glimpses of their true selves. In order for that to happen, we must have time together. We must let our guards down.

I spent time with Whitney. I saw her relax—like when she'd sing with us on stage, doing her thing and having a ball, but in a totally different context than she was used to. I saw her cry, though over the years, they were mostly tears of joy—like when she and Bobby got married or when Bobbi Kristina was born. I saw her nervous—like when she balked at seeing *The Bodyguard* in the theater because there was no telling what people might say. And I loved her for every genuine moment we shared.

The Family—the Winans family—loved her with the same level of commitment, but each in our own way. My brother Marvin not only officiated her funeral but her wedding to Bobby Brown. My sister CeCe—like myself—performed with her, visited her on tour, visited in her home—and was there till the bitter and untimely end.

I loved Whitney like I love my three sisters: CeCe, Angie, and Debbie. And when Whitney left, I felt that sense of love even more.

I could almost taste it.

I could hear it in my mind.

But first and foremost, I could hear her in my very being: the Whitney I knew.

The pages that follow represent my attempt to continue to know my friend, my sister—Whitney. The memories are Whitney's voice speaking to all of us. By reaching back and remembering what she said to me in the past, I not only cope with her loss, but I also give voice to someone everyone loved but few really knew.

Cissy was gracious in saying that I knew her. But so did others whom she loved and held close to her. My hope is that I can honestly portray Whitney in a light that she would sparkle in, while remaining true to the dynamic narrative of her life.

She was vivacious and unruly; she was endearing and infuriating; she was honest and private. And she lived within a level of fame that few on this earth experience. Most of all, I think that is the important thing to remember.

"She is our queen, and she opened doors
and provided a blueprint for all of us."

BEYONCÉ KNOWLES

Our Black Princess

My heart desires each of us to listen to her memory and see if we
can't sift through the tabloids and into the heart of our "American Princess."

BeBe

༄

When my daughter, Miya, was four, she fell in love
with the television movie *Cinderella*. The one in which
Whitney played the Fairy Godmother and Brandy played
Cinderella. We taped it for Miya so she could watch it. And watch it
she did. Over and over and over again.

One day Whitney stopped by the house. The doorbell rang and
Miya ran to see who was there. When she opened the door, she
stood frozen—dumbstruck. Whitney walked in, and Miya ran across
the room and grabbed me.

"Daddy, Daddy! The Fairy Godmother is here!"

Whitney clapped her hands, threw her head back, and laughed. "Oh, Lord! I spent all this time trying to be a singer, and now I'm a Fairy Godmother."

I can just imagine Miya's little mind working—how she would conjure up her little Cinderella world. I used to watch her play in her room. She'd act out both parts, first Whitney, then Brandy. How I'd laugh: my precious little daughter living in the princess world with Whitney.

On that day, when the doorbell rang, my little Miya faced her hero. But in this case, her hero was more than just a character in a fairy tale played over and over on the television. Now her hero was a live human being who took a real interest in her life.

The same woman who played the Fairy Godmother also played the real-life role of Miya's godmother. And maybe at that time in her young life, Miya didn't fully understand the "godmother" idea, but she would over time. Over time she'd see past the glass slipper and the "Bibbidi-Bobbidi-Boo" and into the *real* person. And that time would come by way of laughter . . . play . . . and, later, sadness.

<center>❖</center>

To my Miya and her brother, Benjamin, and to my nieces and nephews as well, Whitney was as real as anybody else. She'd call the house and even stop in from time to time. She held those kids. She played with them. She sang to them. She was around like any friend of the family would be.

The public forgets that behind the glowing television screen a real person lives and breathes and eats breakfast just like

everyone else. A person with friends and even enemies. A person with feelings.

Celebrities get lonely—even if they're superstars.

They get sad.

They get desperate.

They get lost.

They desire to be found.

Whitney wasn't just a singer who wore opulent outfits on stage; she was someone who liked to wear blue jeans and tennis shoes, she liked to play practical jokes, and she loved children. The fairy-tale character on the television found her way into my daughter's heart, but it was even more than that. She found her way into Miya's real *life*. Whitney was like that good friend of the family who every one refers to as Uncle or Aunt So-and-So. No one remembers when or how they became part of the family; they've just always been so. Always family.

Whitney was Whitney. And that's why we all loved her. She brought herself into everything she did. She made the fairy-tale land her own. She brought that sparkle to *Cinderella* (and would later do so as Jordin Sparks' mother in her final movie, *Sparkle*), and my daughter dove into it headfirst.

When I run into people in my community, they ask how the family is doing and they say how sorry they are for the loss of my friend. And nearly everyone says, "I loved Whitney." There was universal upheaval when she died on February 11, 2012. I think people feel as if their Fairy Godmother—or maybe more so, Sleeping Beauty—has fallen asleep but isn't waking up.

I remember Oprah's interview with Whitney a few years ago. Whitney's involvement with "the princess movie," *Cinderella*, prompted

Oprah to call her "our black princess." I would agree. I think she was that for anyone who heard her sing. She was that for my daughter.

But eventually we all grow up and the fairy tales we love to act out in our pretend worlds lose their luster.

My daughter is sixteen now. She just attended her first prom. She dressed up in her pretty dress and walked out the door, her best version of Princess Whitney. But the fairy-tale world has changed now. It changed the day I received a phone call while at dinner with my son, Benjamin.

My phone started going crazy. It was my cousin Cindy.

"Have you heard what's being reported?" she asked.

"No."

Cindy told me what she knew. I hit "End" on my iPhone with a trembling finger.

I tried to call Pat, Whitney's sister-in-law, but as I was dialing, my mom's number showed up.

"Mom?"

"Have you heard?" she asked.

"I'm going to call Pat to find out . . ."

"Oh, BeBe. CeCe and I just hung up with Pat. It's all true."

Everything changed with just the flash of a phone screen.

It changed when Benjamin and I drove to my daughter's work and told her that Whitney had died.

It changed when we cried together.

It changed when I realized my kids were more concerned about me than their own hurt.

<center>⬦⬦⬦</center>

Even now, I look at my phone, thinking she'll call. But she doesn't.

If you can, lean in and listen to that voice—the one that sang the National Anthem, the voice that drew us into *The Bodyguard*. Imagine that voice in the form of a phone call. Can you hear it?

"Hello-o, my bro-tha," she would sing as I answered. Up and down the scale she'd soar—her typical phone greeting to me. We sang our hellos.

"Hello, my bro-tha. Whatcha doin' today? Mmmhmmm."

And of course, I would respond in kind. "Whatcha' doin', my si-ster! Can you get together sometime? Ohh-ohh, mmmhmmm."

We'd perform our conversational opera, she and I. Can you hear it? Not just a voice, but a person behind the voice. The playful sister always wanting to sing, even on the phone.

That same playful girl and I were planning my fiftieth birthday party. Hers would follow the next year. We'd talk about what we'd do for the party and who I'd invite. And now, when I think about that birthday, I only hear an echo of our discussions. It's a heavy echo. And I find myself singing back to it the same way I'd sing to her phone calls. But the echo fades and only my voice skims the empty hallway.

She's gone. And I miss her.

"You wait for a voice like that . . .a face like that,
a smile like that, a presence like that for a lifetime.
And when one person embodies it all,
well, it takes your breath away."

CLIVE DAVIS

Whitney's Weight of Fame

When I started singing, it was almost like speaking.

Whitney

❦

Close your eyes. Imagine yourself walking down the street. Any moment a person with a camera could appear—*skeet-skeet, skeet-skeet*—capturing your image for the world to see in the tabloids the next day. There you are, plastered on cheap paper for everyone at the grocery store to gawk at as they pay for their fruit and toothpaste. Imagine how you would think about your day. How it would change your routine to have to prepare yourself for the possibility of being stopped by anyone and everyone, just so they can have a picture of you.

Now imagine that you're intensely relational—a real people person. You love connecting deeply with others. You love your friends. And not just with a "you're a great person" type of warm fuzziness, but a savage love that wants and pursues friendships—that longs to be inside the hearts and minds of others.

Keep your eyes closed and continue imagining. Not only do you love people with every ounce of your being, not only do you thrive on personal loyalty and get lost in the security of your friendships and family, but you're stalked by the international media. Suddenly, it's hard to keep friendships private and family loyal.

In fact, it's hard to keep anything private. You're cut off from a normal life. Why? Because you pursued fame?

No. Because you possess a gift.

This gift was given to you by God, and you know it. You sense it when you use it. You communicate to people on a beautiful and mysterious level when you sing, and you love to sing. And suddenly millions of people the world over love to hear you sing. They love your gift.

Oprah calls you "The Voice" and will say after your death: "We got to hear a part of God every time she sang." The first time Tony Bennett hears you sing, he phones your mentor, Clive Davis, and says, "You finally found the greatest singer I've ever heard." Music critic Ann Powers of the *Los Angeles Times* calls you a "national treasure" and writes that yours is one of those voices that "stands like monuments upon the landscape of 20th-century pop, defining the architecture" of your era. *New York Times* music critic Jon Caramanica calls your gift not just "rare" but "impossible to mimic." Oscar winner Jennifer Hudson tells *Newsday* that you have taught her "the difference between being able to sing and knowing how

to sing." Lionel Richie states to CNN that you knew how to "turn a
. . . melody into magical, magical notes." Fellow songstress Mariah
Carey deems yours "one of the greatest voices to ever grace the
earth." And Celine Dion—a peer if ever you had one—describes
your voice as "perfect."

You are honored by your industry, your peers, your fans—and
even MTV (they put you third on their list of the 22 Greatest Voices)
and *Rolling Stone* (which says that your true greatness was in your
"ability to connect with a song and drive home its drama and emo-
tion with incredible precision"). What's more, you become the most
awarded female artist to ever walk Planet Earth, with hit songs in
nearly every *Billboard* genre and sales of more than 170 million al-
bums, songs, and videos.

Companies clamor to bottle up your gift so they can make a
buck. Oh, and they'll give you some of that money too. That's the
game. It's played with exorbitant amounts of cash, which makes
things easy for you—or so it would seem. You ride jets all over the
world. You own several homes in the best cities. You can literally
have whatever you want. Nothing is off limits. The world is for sale,
and you're buying. That's the perception *and* the reality.

It all seems so surreal, like you're watching it happen from the
outside, looking in. And it's all because, when you step up to the
microphone, you light up an arena. But the tension and mystery of
your fame runs even deeper. You love to share your gift—and it's
not about the money or the trappings of fame. It's in your blood.
Your mama sang, your family sang. It's what you do. It's what you've
always done.

But it's not *just* that you sing. It's that you sing from a place deep
within. The world burgeons with great singers, but only a few voices

make people stop and listen and cry. You're one of them. Not by choice, but by Design. And it just so happens that you find incredible joy when you lose yourself in a song.

You tell Anthony DeCurtis of *Rolling Stone* that when you'd watch your mother sing in church, you'd get "that feeling, that soul, that thing . . . like electricity rolling through you"—the same thing you experienced when the Holy Spirit would be on the move in a worship service. "It's incredible," you said. "That's what I wanted."

The world watches you get lost when *you* sing—they get lost with you. That's what makes you special. That's what separates your voice from all the others.

Is it worth the pressure and everything you give up when you use it? Sometimes.

Achieving fame doesn't happen on a whim. Sure, we live in an age where YouTube creates overnight success stories. But more often than not, those flames burn out as quickly as they flared up. True fame, on the other hand, is birthed. It begins with a gift. In Whitney's case, it was the gift of a voice and the infusion of a soul that loved deeply all the time. And when those two components mix, you have something uncommon. That's the Whitney I knew.

She lived in the tension of wanting to love those she was close to—to be gregarious and spontaneous because that's *who* she was—and dealing with the tremendous pressure and demands of her fame. It was a fame birthed from her incredible gift, a gift everyone wanted—the kind of gift that gave us that "Star-Spangled" moment.

Hers was a tangible gift that audibly and even visibly set her apart. That's what Whitney possessed. There was no gimmick to her, only giftedness. But with that giftedness came great promise and

great responsibility, the weight of which can be too much for even the most pure in heart.

The world saw Whitney in the tabloids just like it sees Madonna or Brad Pitt and Angelina Jolie. Our mistake is that we make our assumptions about the kind of people they are based on the manipulative lenses of photographers scrambling to land their photo on the front page of the tabloids. We watch *Being Bobby Brown* and think that the scenes caught on tape constitute Whitney as a person, a mom, and a wife. True, the reality show was not Whitney's (or Bobby's) shining moment. But are we really that eager to remember someone for their worst moments when they've given us so many of their best?

The truth is, those images never constituted Whitney's reality. Her life was not lived at the reality-show/tabloid level. And yet, because that's all so many people saw, it's all they allowed themselves to believe. The public formed their opinion of her through writers and photographers who never met her. To me, that's a tragedy.

Imagine yourself in this situation. You can't escape the expectations of the mob. And it kills you.

It's like what one writer wrote in the *San Francisco Chronicle* when remembering Whitney as a role model: "I'm not talking about the Whitney who succumbed to . . . erratic behavior. Lord knows that the crown—six Grammys, 22 American Music Awards, well over 100 million albums sold, 'Most Successful Female Solo Artist of All Time'"—must have been heavy to bear." Absolutely, it was heavy to bear. And when the expectations of the mob join with the pressures of stratospheric fame, you can begin to doubt your own identity, which can ignite a desire to get it back no matter the cost.

<div align="center">❖</div>

Sometimes we think we own those in the public eye. We buy an album and, back in the day, we'd haul it around in our Walkmans or keep it spinning on our record players. Now we can literally carry songs in our back pockets, keeping little pieces of our favorite artists with us at all times. Some people think this entitles them to a part of that celebrity's life.

Luther Vandross once told me of a time when he was riding an escalator up and a lady who was headed on the *down* escalator recognized him. She made a big fuss when Luther didn't stop and sign something for her, blurting out, "I'm never going to buy another one of your albums again!"

Though Luther couldn't stop—he was on an escalator!—when he reached the top, he immediately hopped the *down* escalator. Upon catching up to the woman, he asked, "How many of my records do you own?" The lady quickly rattled off several titles. Luther then reached in his pocket and paid her a couple hundred dollars and said, "There, that should cover it. I never want you to buy my records again. You don't own me!"

I think Whitney felt all the time like Luther did that day. She couldn't go into a restaurant and enjoy a meal without someone coming up and saying, "I don't mean to bother you . . ." *Don't mean to bother you?* Whitney was gracious to people, but she still was never able to eat a meal uninterrupted when in public.

Whitney bore that weight. And yes, she embraced it at some point, but it never becomes less of a burden just because you acknowledge it as your reality. It's always with you. It was always with her.

When you and I see a famous person like Whitney flying all around the world, singing in front of hundreds of thousands of

people, we marvel, "That must be the life." In some ways, it is an incredible opportunity, but not without its share of darkness. When you and I are sick, we can call in to work and take a sick day. But when 20,000 fans become angry and demand their money back, and the concert promoter then wants to turn around and sue you for millions of dollars if you fail to deliver the goods, you must learn to cope. Let me break this down for you so you can understand how the pressure links back to the talent—the performer.

Let's say you're a major act like Whitney was, and a concert promoter in London agrees to pay you $2 million to come to his venue. That promoter must then pay for event insurance and marketing and must also pay to fly you and your entire band to the venue. Maybe the promoter struck a deal with Coca-Cola, who agrees to sponsor the event (this means they will pay the promoter a huge sum of cash) with the contractual understanding that they can sell Coke at the venue exclusively.

If you fail to perform, more than an "I'm sorry, I won't be able to make the event" will be demanded of you. The promoter, now with millions of dollars fronted to make this concert happen, is about to be sued by Coke and other vendors. Not to mention the money he paid to get everyone to the venue. The dominoes fall, and in this fictitious scenario, you would be the one to take the fall.

This is a very simplified picture of what happens, but hopefully it paints a little of the scene for you.

When entertainers sign the dotted line, they are promised huge sums of money. But the Bible says that to whom much is given, much is required. And that principle holds true in this situation. The performer will receive millions, but they are also on the hook for millions if they fail to deliver.

The pressure to perform and be on top of your game can overwhelm even the most grounded celebrities. It's more than any one person can deal with.

Another diva (and sister in the Lord) who knew what it was like to be a longstanding premiere act atop the music world was Donna Summer. In a 1978 *Rolling Stone* cover story, Donna admitted to Mikal Gilmore: "Sometimes it gets to the point where you've been pushed for so long by this . . . monstrous force, this whole production of people and props that you're responsible for, by audiences and everything that rules you, until you take it upon yourself to be a *machine*. And at some point a machine breaks down. I feel like I want to cry most of the time and just get rid of it, but sometimes I get so pent-up, I can't. And that's when I get afraid."

That's why Whitney loved her friends. That's why she wanted family around her constantly. That's why she'd call me from London and ask me to hop on a plane just to hang out with her. That's why, when I did hop that plane to be with her, she lovingly coerced me to continue on to Paris. That's why she and her assistant, Robyn Crawford, coaxed me into buying some ridiculously expensive leather jacket that was way too lavish for me. She loved deeply and wanted to be loved deeply in return, and when she was, she felt safe and at home.

We all feel that way, right?

In order to keep some semblance of normalcy, Whitney held on to the little things of life. Little things that you and I take for granted—like driving a car—helped her keep life in perspective.

To Whitney, getting behind the wheel was one way to feel like a

real person again. She *loved* to drive. The problem was, she was a horrible driver! It makes me laugh even now to think of how she'd want to drive us around when I would show up in Atlanta. I'd tell her, "Girl, I don't want to die today. So *I'm* driving."

No way. She'd have none of it. She wanted to drive, and when she wanted to do something—look out! One time we drove around for forty-five minutes because she couldn't find her house!

Driving the two of us around? Pure gold to Whitney. She could talk to me on those rides around town. She could laugh like she so loved to do. She could let it all hang out.

Not all celebrities pursue the "glamour" that comes with the occupation. If it meant being normal for an hour, Whitney would rather get lost on a mini-road trip in downtown Atlanta than be flown to some exotic concert destination. She liked going to her friends' homes to hang out—as she sometimes did with Pauletta and Denzel Washington. She adored going to the mall, but after about five minutes, there'd be a train of people behind her. She also loved going to movies. But that, like everything else, came at a price: the price of privacy.

She didn't want to give up her public life, but it was taken from her by a force beyond her control. Some stars, like Whitney, would sing background vocals the rest of their lives if they could. If it were possible to perform and use their gift in some kind of anonymity, they'd do it in a heartbeat.

<p style="text-align:center">�„⋅⋮⋅„⋅</p>

Whitney saw that desire for "normal" in my sister, CeCe, who she nicknamed "the reluctant star." We already had named CeCe "Betty

Crocker," because while my sister loves to sing, if she had her way, she'd sit at home and sing while folding laundry.

At some point, I realized that, buried in that little "reluctant star" moniker that Whitney gave to CeCe, was a window into Whitney's own heart. And I think she'd admit this today if she were still with us.

Singing was Whitney's escape. On one occasion in 2002, Whitney and Bobby (Brown), my brother Marvin, Gloria Estefan, and Stevie Wonder, among others, attended the opening of the One and Only Resort, another property of the Atlantis Hotel in the Bahamas. They showed up as part of the audience. They weren't there to sing; they were there to be with friends and to enjoy the evening. But then I asked each of them to the stage. And that's when the magic happened. ◼ GO TO TheWhitneyIKnewVideos.com TO VIEW THIS AND OTHER BONUS MATERIAL.

There we were, on an outdoor stage under a tent in the Bahamian night, singing our hearts out. No one getting paid, no egos. Just a bunch of "family," making music and having the time of our lives. Stevie played and led us; Whitney, Marvin, and I sang backup. This was Whitney at her raw best. We sang songs we didn't even know, telling each other the lyrics right before we had to sing them!

There was very little fanfare, yet you could taste the energy in the air. You could feel the intimacy on the stage. When Marvin would take the lead, Whitney would lean over and whisper in my ear about anything and everything—hilarious, crazy stuff about her and Bobby, or silly stuff about us all being on stage together and not knowing the lyrics to the songs we were singing, or pointing out things about people in the audience. She was like a little kid on the playground. But that's what made her so lovable, and that's why people were drawn to her.

You won't find a video of this performance on YouTube—it's only available through this book. In the hands of family. And that's exactly how Whitney would have it. For her, that night was like being back at church, singing for the joy of singing.

There was that burst of energy we saw in her iconic pregame performance at the 1991 Super Bowl, but here she was giving the same passion and energy to a crowd of a few hundred (at most). I think it was those times of intimate singing with those she loved that invigorated her spirit. Those times when she was able to sidestep fame and walk in a different direction for a time, letting that heavy weight fall from her back and spreading her wings a bit wider.

Nights of pure singing and laughter and relationship like the one we experienced in the Bahamas watered her soul. But when you're Whitney Houston, those nights are rare.

Whitney's reality at the height of her career was intense. Her fame limited what she could share with people and with whom she could share it. She couldn't tell just anyone that she'd had a miscarriage, for example, for fear that word would leak to the public. If one person outside her trusted inner circle found out, then suddenly the world would know. And if the public was going to be told, she intended to be the person to do it. But it was difficult for her. She couldn't grieve like a normal person, and that makes it tough to process the pain. In times of deep loss, she would find herself trapped in a dark place, with grief a lonely friend.

Could Whitney rock a stage to the ground? Yes.

Was Whitney at home singing backup for CeCe and me or singing with her friends at some random stage in the Bahamas? Yes.

That's the Whitney I knew.

She didn't possess a hunger for fame and notoriety; she possessed a hunger for seeing others thrive and find success.

Whitney loved talented people. With Anita Baker's 1986 single, "Caught up in the Rapture," she remarked to me, "Did you hear this girl, Anita? Oh! Love her." That was true Whitney. That was part of the joy of Whitney: she just loved hearing and finding new talent. For her entire career, she was constantly encouraging other singers—the new arrivals to the frontlines of fame. So many women, from Alicia Keyes and Brandy to Beyoncé and Kelly Rowland and Rihanna, have credited her as far more than mere influence and inspiration. They were recipients of her personal encouragement, away from the cameras.

From sending cards and flowers to keeping moments light with her humor, Whitney individually reached out to so many of the rising stars who she inspired. Monica, who'd been befriended by Whitney at age fourteen, remembered some of those personal touches that were representative of Whitney's ways. She told *E! Online* that just before Whitney's death, Whitney had visited Monica and Brandy's rehearsal for their upcoming tour, and when Whitney heard how Monica ended one particular song, she joked, "You killin' that run at the end. . . . You know I know you stole that from me, right?" Monica also recalled in a *Vibe* interview what many of Whitney's friends would echo: "I went through a lot of very tumultuous moments and [Whitney] would show up, not just with a phone call, but physically. . . . That's something that I've carried with me. . . . [She] never turned her back on the people she cared about."

And contrary to popular thought, she loved to hear Mariah Carey sing. When Mariah burst onto the scene, Whitney called me and asked, "Did you hear that new girl, Mariah? Good Lord, she can sing!"

<center>⬥</center>

To give you an idea of how the media twists reality, allow me to expound on the Mariah Carey situation. Now, this story would probably embarrass Whitney a little, but I have to tell it. I think she'd understand that it's all in good fun.

When Mariah debuted, I'm sure people in the media couldn't wait to compare her to Whitney. I had heard of Mariah early on because my good friend, Rhett Lawrence, produced her first big single. I was at his house in California when he was raving about this new singer.

Well, as we all know, when Mariah came on the scene, she hit hard. And instantly the media created a "hate" between Whitney and Mariah. They were both going to be at the American Music Awards, and people were expecting some kind of fireworks because supposedly there was this massive tension between them. Again, this was a fabrication. They didn't hate each other; they didn't even know each other.

I could convince Whitney to do anything—pranks or whatever. We'd be hanging out and I'd tell her to do something, and she'd say, "You are not my father. Why do you think you my father? You think I'll just do whatever you tell me?" To which I'd reply, "Shut up, I am your father"—all in good fun, of course.

Well, we were at the American Music Awards, and I had persuaded Whitney that after her performance and her category were over, we would go to dinner. I'd also informed her that when we exited our seats, she would be the last one out, and that we were going to pass Mariah Carey on the way out.

"Here's what you do," I said. "You gonna stop and you gonna put out your hand and you gonna speak to her."

"I'm not gonna speak to her," Whitney replied.

"Yes, you are. You're going to be bigger than this whole situation."

"I'm not . . ."

"Yes, you are."

Her category finished and our little foursome started marching out to go to dinner—CeCe in front of me, Whitney's assistant, Robyn, in front of her, and Whitney at the end of the line—just like I said. And Whitney did exactly as I told her to do. I didn't stop to listen to or watch their interaction; I just kept moving. The three of us piled into the car, and then Whitney blew in like a storm and slammed the door behind her. She was clearly upset and embarrassed.

"I'm going to kick your tail!" she said to me.

"What happened?"

"I'll never listen to you again."

"Tell me what happened!"

"I did everything you said: I stopped. I put out my hand and said, 'Hi Mariah, I'm Whitney.' And when I stuck out my hand, she turned her head like she didn't hear anything I said and looked up at the sky."

"Oh no," I said. "Tell me that's not true."

"Oh, it's true. I was so embarrassed. There I stood, looking like an idiot. I'm never going to do what you tell me to do again."

Thank God the media didn't see this. If they had, Whitney's and Mariah's brief exchange (or lack of it) would have been blown into epic proportions. They would have hated each other and not even known why—and all because it may have been so chaotic in that moment that Mariah didn't even hear Whitney. Unbelievable.

Well, my idea didn't go very well, but we laughed at that whole awkward affair years later. And this incident didn't end up stopping

those two from getting together in the future . . . after some further persuasion.

Before Whitney was approached with the opportunity to record a duet with Mariah, I encouraged her to do one with her.

"You crazy," she responded. "You know what happened last time I tried to do something nice. You don't know what you're saying, boy. You've lost your mind."

It wasn't that she disliked Mariah; she just didn't want to be embarrassed again. We talked a little more about it, but she finally said, "That ain't going to happen, BeBe."

Then, only a few months later, she called me and sheepishly informed me of her latest news.

"Well," she began, dragging it out a bit, "you said it a few months ago—that I should do a duet with Mariah."

"No," I interrupted, "don't tell me you're doing it!"

"Yeah, Babyface is producing it—and it's on."

I could tell she was very happy about the whole thing.

"Wow," I replied, "ain't that something! That's going to be incredible! But wait, you said you were never going to do something like that."

We both laughed and laughed. Oh, how Whitney loved to laugh.

Finally the two superstars met—two musical powerhouses who knew who they were outside of the pop world. And when they performed that Oscar-winning song together ("When You Believe" from the *Prince of Egypt* soundtrack), it was the catalyst for a great friendship between them. When I looked at Mariah at Whitney's funeral, all those memories came flooding back.

I share that story for two reasons. First, as an example of the gross exaggerations the media likes to spin on celebrities and also

to communicate Whitney's honest love for her peers. She loved other singers and was always up on who was new and fresh. Second, I wanted to depict the scene within the church the day of her funeral. Each person sitting in that sanctuary represented both the good and the bad of Whitney's life.

When I say good *and* bad, I simply mean the wonderful make-up of this life in general. That's what makes life so beautiful: the fun and the boring, the misunderstandings and the epiphanies. All of it mixes together on the canvas of our lives. When I saw Mariah at Whitney's homegoing, I saw a specific brushstroke of Whitney's life. That brushstroke touched other brushstrokes. Together the strokes formed a masterpiece.

All masterpieces have certain tensions or contrasts on display—that's what makes the painting dynamic and memorable. Whitney's life told a dramatic story filled with contrast and beauty, a life truly lived.

<div align="center">❖</div>

The seclusion of fame damages people the most. Fame causes its inhabitants to live afraid—to fear their reputation being marred—which makes seclusion seem the only real alternative. Look at how Michael Jackson faded into eerie reclusiveness, buying a monkey and other exotic animals as pets. For me, that seems far removed from reality and true human connection. But he also endured a level of celebrity that few people on earth can relate to.

One year Whitney threw an exclusive party—a BIG party. You may ask, who throws a party for their twenty-sixth birthday—complete with a who's who of attendees, loads of food, a beautifully decorated

tent, and excellent music? Well, she did, because she was on the road during her twenty-fifth birthday.

The invitation had a spectacular picture of Whitney on the cover. You had to be on a list, and there were different security checkpoints. CeCe and I just stayed on the sidelines of the party, watching her enjoy the evening and all the love as she mingled with everyone.

That was also the night we discovered that Michael Jackson had given Whitney a monkey as her birthday present. Everyone seemed amused, but I'm sure they were all thinking the same thing I was— *This is crazy! Who gives monkeys to people for their birthdays?*

The thought is funny and ridiculous at the same time. Of course Whitney didn't need a monkey! It was all she could do to take care of her cat! But perhaps Michael was so far removed from people that he thought Whitney could use the companionship of a monkey.

Whitney couldn't believe it. She looked at me and said, "What am I going to do with a monkey?"

We both laughed.

"As soon as this party's over, that monkey is getting dropped off at the zoo!"

Did this gift make sense to Michael? I don't know. Perhaps. The amount of fame that Whitney had garnered already as a twenty-six-year-old had propelled her into a lonely way of life. But can you imagine thinking that another person would be so lonely that they'd need a pet monkey? This was someone's reality?

This is what seclusion does to a person. Whitney didn't struggle with the inclination toward extreme reclusivenes like Michael did, though I can see now how that gift from Michael was a foreshadowing of the turbulent days ahead for Whitney.

"When we met her, I just said, 'Oh, Lord.'
Because I knew she would be family.
And that is exactly what happened."

◆◆◆

REV. MARVIN WINANS

Bloodlines, Elvis, and Her Eternal Fan

> In my life, it was not that I said, "Well, I'm gonna entertain" [or]
> "I want to be an entertainer." It's in my bloodline; I can't help it.
> It is something that God said: "This is what you do." It's in me.
>
> Whitney

❧

The first time I heard Whitney sing, I was riding in a cab. It was one of those experiences where you hear a song more or less in the background, but it grabs you and leaves you speechless. Don't you have a certain song that always brings back a very specific memory? I can still smell that old cab I was riding in and hear this nameless voice soaring smooth and effortless over the cheap car radio. I waited for the DJ to name the singer, but he didn't.

"Who was that?" I yelled. I was talking to myself, but I'm sure the cab driver was surprised at my passion. I *had* to know!

The singer had that *special something* that few singers ever tap into. I heard the distinction immediately. It's what made me push *Pause* on my day and take note. Though I was frustrated to step out of that cab without knowing that singer's name, eventually providence would have its way, and I would receive the blessing of being introduced to the owner of that stunning voice.

That blessing materialized in 1985 when my brothers Marvin and Ronald attended a Jeffrey Osborne concert with me on a beautiful summer evening in Detroit. A tall, skinny, poofy-haired girl opened the evening and stole the show—no disrespect to Jeffrey. That night I was able to put the voice with a face.

I grew up in the church, singing gospel before I could say my ABCs. I was weaned on the great "soul" that accompanies gospel music. So, when I was finally introduced to this skinny girl with the big voice, I had one question to ask her: "I don't want to hear your nickname or anything else about you. I just want to know what church you're from. Because when I hear you sing, I know you *have* to come from someone's church. So, which one?"

And thus marks the moment when I saw that famous Whitney smile—the one that started at her left ear and attached to her right. The one that said, "I got you," while at the same time saying, "Let's paint this town with song."

"New Hope Baptist," she replied, beaming. I would later find out that New Hope was the church she grew up in—the site of her first public solo as a young girl.

All I knew that night was that she came from a church. A voice like hers had to have been molded by the halls of worship.

Sure enough, she hailed from East Orange, a suburb of Newark. (Her parents moved the family out of Newark after the riots, when Whitney was four years old. Her church was located in the heart of Newark. So she was a Jersey church girl. That said it all to me.)

Eternally and instantly, I was a fan—all of the Winans were. And it turns out she was a fan of ours as well. That night she had sung my brothers' song "Tomorrow" in her set. I had no idea she knew my family, but she told us that she listened to our music every day.

From that time on, we weren't just friends, we were *family*. And even then, she loved having us around—being together, talking, acting crazy. But it was a good crazy. Not the crazy you get when fame slams into you like a wrecking ball.

In some ways she was an enigma to me: the so-fun-and-crazy Whitney—and then she'd sing. From that crazy girl rose this *voice*. It was the stop-you-in-your-tracks voice I heard that day in the cab.

I had a hunch that the mystery of Whitney that drew me and my family to her would blossom into something great. Many people had that same hunch. But did we ever think that blossom would later become something so delicate and rare?

If anyone was born to sing, it was Whitney. Some people may call it dumb luck—I call it God. Whatever you want to call it, this much I know: God placed Whitney into a musical family, a legendary one. Her mom, Cissy, possessed a powerful voice in her own right and formed the Drinkard Singers, a gospel group in which her sister, Lee Drinkard, sang as well. Lee was the mother of Dee Dee and Dionne Warwick. Cissy also formed the Sweet Inspirations, who then sang backup for the likes of Elvis Presley, Van Morrison ("Brown-Eyed Girl"), and Aretha Franklin. Talk about a bloodline!

To top it off, Aretha Franklin—or "Aunt Ree," as Whitney called her—was Whitney's godmother. That's no dumb luck, my friends!

It was the soulful singing of Aretha that Whitney sought to emulate as a young girl. Aretha Franklin has always been known to possess that quality that allows her to communicate on a very personal level with her music. That's why we call her the "Queen of Soul." But the woman has gospel in her veins.

In 2012, she'll be inducted into the Gospel Music Hall of Fame. And her 1972 album *Amazing Grace* is still one of the best-selling gospel records of all time. If you haven't heard Aretha's version of the title song, well, listen to it. If you're lost, you'll be found.

<div align="center">⬥</div>

When you consider Whitney's bloodline and influences, the path she took was no surprise. She was a thoroughbred singer, mentored by some of the great gospel singers of a generation—arguably of the past century. I think it was the mentors in her life that kept Whitney from spiraling early on, like so many young entertainers do. It was also these mentors who modeled a life in music—what that meant, the joys that came with it, the responsibility of having talent. The women in her life not only showed her how to sing, they showed her how to be a singer.

It didn't hurt either that her mother and father maintained a firm rein on the household. It was because of their guidance that Whitney was able to benefit from a simple and rich upbringing—the same kind of life I know she wants for her own daughter. Whitney received several contract offers when she was a teenager. But Cissy and John, her father, made it clear that she was to finish high school

before she started down the entertainment path. They only signed with Clive Davis after they vetted him thoroughly.

It's easy, sometimes, to look back on our childhood and resent things. And some of us have good cause for that. But Whitney was not only blessed with a voice, she was blessed with family and close friends who supported her and loved her enough to tell her *no* when she needed to hear it. We don't like rules very much. But rules and standards empower us. They instill confidence—a confidence that comes from knowing someone cares enough to do what is needed and right for you. That's what Whitney had. And that's what I heard during that cab ride. A young voice but confident; a young singer who knew who she was; a voice searching for the pool of passion deep within that song.

In the commemorative Whitney edition of *Life* magazine, Dolly Parton reminisced about the time she praised Whitney for her performance of Dolly's song, "I Will Always Love You," on *The Bodyguard* soundtrack. At the time, Whitney received the compliment with grace, but she also, in her humility, deflected it. Dolly insisted then, and still insists, that no one else could have done what Whitney did to that song. How true. I call that *the Whitney effect*. But Whitney would probably tell you it had something to do with the Aretha effect.

Whitney had the uncanny ability to not only draw from that "Aretha well of soul" deep inside her, but she was able to revitalize a song—making it totally her own. Dolly's version of that single was just fine, by her own admission. Whitney's version broke sales records that still stand today.

Whitney knew where that *thing* came from. She said as much when I asked her what church she attended the first time I met her. Her smiling answer gave her up.

Some things are so clearly given by God. When you hear someone like Whitney sing, it might be easy to say, "Well, look who her mother was; look at her relatives. They were all so talented." I think that's true. But it's more too.

It was the church in her. The gospel passion fused into pop. When you combine that with one of the greatest voices of all time, what do you get? That's not only family heritage or good mentoring, it's heaven's gifting.

Whitney always recognized God and his impact on her life. That's why she beamed when I asked about her church. That's why she often told the media that it was important for the men in her life to love the Lord. It was a gospel song that broke Whitney into singing to begin with: "Guide Me, O Thou Great Jehovah." That wasn't just a song to Whitney. It represented her prayer and desire. She pursued God and loved her gospel roots.

<p style="text-align:center">⬦</p>

I was talking to a friend of mine the other day about how so many people that I meet in the entertainment business grew up in the church, and yet, for whatever reason, many of them have left it. Who knows why? Maybe the church hurt them or they just grew to resent God. Still, it's interesting to me that even though so many revile the church or never find their way to it to begin with, they end up walking down the aisle in a church to speak vows to the person they love. And then, eventually, they sit beside family and friends in a pew listening to people eulogize someone they loved.

Life tends to drive us to church, at least on occasion. Even more, life tends to drive us to God.

I think Whitney would have loved to sing and say something at her funeral. She loved being in church. There she found Jesus, and there she stepped into her calling, singing the gospel numbers like her own lifelong doxology.

That night in Detroit when I first met her, I knew she would have to walk out of the church and into the world. She had a job to do— to let the people hear what church sounds like; let the people hear what God sounds like. Ironically, I think the world got a sampling of that at her funeral. At her church.

What does God sound like? Whitney singing the high-soprano line in a song? Well, maybe. But in all seriousness, I think God sounds like the gift he's given to each one of us. We're free to use our gifts in any way we see fit, but God's plan for those gifts—his desire for those gifts—is for you and I to return them to him by using them, and then by giving him the honor he is due. I also think we honor him with our gifts when we employ them to show compassion to the less fortunate—by serving the impoverished and feeding the hungry, as Whitney did so many times through her charitable work and appearances. Many people don't know that she formed the Whitney Houston Foundation for Children and also supported the United Negro Fund, the Children's Diabetes Foundation, St. Jude's Children's Research Hospital, and various other causes.

Famous or not, when we use our gifts for God's glory, we accomplish something amazing: we change the world's view of what love looks like, of what love is. The Bible says that love is patient; it is kind; it gives sacrificially. In my mind, such resounding love is exactly what God sounds like.

"Whitney was not just a friend but a sister,
and I am going to miss her voice and her humor,
but mostly, her friendship."

CeCe Winans

The Pact

Oh, this looks like something in my brother's house. Does this belong to you?

Whitney

❧

Early in my relationship with Whitney, she invited CeCe and me to her crazy-beautiful home in New Jersey for lunch. She didn't care too much that it would mean booking a flight up the Atlantic Coast for us (we lived in Nashville).

Little did we know then that Whitney asking us to "come over" for something like lunch would become a common occurrence.

Whitney's Aunt Bae—her dad's sister—worked her magic in that amazing kitchen and whipped us up some fine home cooking. And at the lunch, Whitney announced: "Okay, we're makin' a pact."

I'd never made a pact before, so I didn't know what she was talking about. "Y'all promise me that we'll be there for each other through it all; that we'll remain *family*, and that we'll be with each other, no matter what," she said, her eyes gleaming and intense.

It was like wedding vows—"till death do us part"—or a scene in a movie where a bunch of kids cut their hands, shake, and become blood brothers or sisters. Basically, The Pact was this: we made a solemn promise to one another that we'd always remain close and that, more specifically, we wouldn't make any life-altering decisions—like getting married or signing a big contract or other career-type stuff—without consulting one another. Nothing was to happen without everyone being involved. That was the deal.

We didn't draw blood that day, but we were serious about The Pact. Nothing would be off the table or off limits, not even family. It was understood that we would talk about everything and anything. No subject was too big or too small; fear would have no place in our relationship. The Pact made it so.

Before the trip, CeCe and I had wondered: why this invitation to fly in just to have lunch and hang out at Whitney's? Now we knew. The Pact was the reason. The Pact and . . . to spend time together like families do.

I remember CeCe was a bit tentative about going, but I told her we should do it—and we were grateful for our decision to go. Because that day The Pact was born, and so was a forever kinship.

At the end of our time together that day, Whitney cried. So did we.

She didn't want us to leave. We didn't want to leave.

The whole experience was overwhelming.

It was so much more than a simple lunch. And so much more than a great meal with the biggest superstar in the world at her

house. It was true family time while the three of us sat around like kids on summer vacation—just hanging out and talking about life and dreams and what was coming next.

I confess, at first I had to contain myself at being treated by this singer, who I was such a fan of, in this incredible house. It was huge and spacious, lived in and warm—just like Whitney. But the day certainly wasn't all serious either. Whitney showed us around her sprawling home, and when we got to the garage, there was an enormous stash of Diet Coke. As an avid Diet Coke drinker, I'll never forget it! Yet I never, ever saw Whitney drink even one!

Fly in for lunch. It makes me laugh to think that, on a whim, we flew up there to eat. I couldn't believe how much she desired to be close. That's how she drew us in; that's how she drew others in. She spent time, precious time, being with the people she loved.

I'm sure you've done something in your life that you know was "meant to be." That's how I felt on the flight home that evening: like we had experienced something that God had ordained for us. To think that I had gone from hearing an unnamed gifted singer in a cab to this—to becoming family with this person—was hard to grasp. If you'd told me in that cab that I'd soon find out so much more about this singer than just who belted out the lyrics, I would have laughed at you.

But it was meant to be. God made it so. And that's what makes it so special to me now. God ordained our relationship, and under his plan, so much in life materializes and is set in motion. Nothing, I've found, is so big that it falls outside of his plan. Not even death.

That cab ride changed my life. It set me on a trajectory that flew me straight into Whitney's life.

God orchestrates our lives for a specific reason. There's purpose behind every event. I'm convinced that even the bad times in life carry meaning, if only to show us that we need others to help us carry on or to show us that though God allows grief, he also demonstrates compassion through his steady, unfailing love.

The Pact was sealed on that day in New Jersey. Yet it wasn't so rigid that we didn't give each other the space we needed. From time to time I'd remind Whitney, "If you need to talk to me, let's talk."

"I know, I know," she'd say.

She knew the relationship was there; she had access to our friendship whenever she needed it. But I also didn't push or hold The Pact over her head like an obligation. To truly love someone means not pushing if you don't need to. To love is to listen. That idea was so powerful to me when I learned it from a friend, and I wanted to be that kind of friend for Whitney. She knew she could always talk to me, and boy—did she ever!

Our conversations covered the map—literally and figuratively: We talked about where she was when she was traveling overseas. We'd debrief about concerts. She'd tell me how much she missed home and wanted to be near her friends and family. She'd talk about personal battles too—whatever she was struggling with at the moment. She'd talk to me about songs, ask about my writing experiences and where I got inspiration . . . things like that.

Sometimes she'd talk so much, it spun my head around. Anyone who was close to her will likely tell you the same: the girl loved to talk, till all hours of the morning even, like a kid on a sleepover. One time she called me from Hong Kong and we talked for four hours! I

told her, "If they make a mistake and charge my phone, I'm going to be homeless. Because I can't pay that bill!"

"Boy," she said, "they ain't gonna charge you."

"Okay," I countered, "but if I get a bill, it's coming straight to you."

That's what she needed, though. She needed an ear to listen. She needed a quiet spirit with which to abide. I tried to be that for her when I could, because I knew that if I listened to Whitney, she would interpret that as me loving her. *To love is to listen.*

One of the great things about Whitney, though, was that friend-ship wasn't just a one-way street. Just like she said in The Pact, it was about us being there *for each other.*

I learned early on that sometimes people do things for others for mere bragging rights. You know the type—that person who likes to help so they can tell someone about it? Well, Whitney was different in that way. For Whitney, once you were family . . . hold on!

One day in 1989, she called and told me to pick her up from the airport—she was just dropping by like she did from time to time. My wife and I were living in a one-bedroom apartment back then, and we offered Whitney the bedroom, but she opted for the couch.

The next morning a friend came by to pick me up, and as I was trying to slip out of the apartment without waking her, the sun broke through and she lifted up off the couch with her hair going in every direction.

Keep in mind, this was when she was becoming *the* Whitney Houston—with seven consecutive number-one Billboard hits, in-cluding, "I Wanna Dance with Somebody (Who Loves Me)." I started laughing and said, "If the world could see you right now, I don't

think they would *want or choose* to dance with 'somebody.'" We both chuckled.

Then she inquired, "Where you goin'?"

"I just have to run out quick."

"Well, when you getting back?"

"I don't know; I won't be long. Why?"

"Get back here soon. I want to see this house you're lookin' at."

She knew that I was thinking of buying a house—my first house. She was determined to see it.

Just like everybody else, I longed to live the American dream and own my own house. But I was already starting with the odds stacked against me. I didn't have much credit, and I was a musician. Banks don't look too fondly upon musicians. We're high-risk—which is an easy excuse for them to say no.

Getting a loan would be an uphill battle, I knew, but I was more than willing to fight this battle.

From our previous conversations, Whitney also knew the bank had decided at the last minute to change the amount of the down payment I needed on the house I'd picked out. At first they told me that, if approved, I would need $25,000 for the down payment. But then, after I was approved, they changed the amount to $75,000. I was caught off guard and had no way of obtaining that kind of money on such short notice.

When I returned to the apartment, Whitney kept talking about how her purse was bothering her—and she'd been doing so ever since I'd picked her up at the airport. She was also unrelenting about seeing the house, so finally I drove her over to the place. As we walked through it, Whitney wouldn't stop talking and acting funny. When we walked into a room, she'd comment, "Oh, this looks like

something in my brother's house. Does this belong to you?" In the hallway she'd say, "Oh, BeBe, look at this staircase! It's beautiful. It looks just like my brother's staircase."

Because she kept on like she was, I decided I'd just keep on walking and ignoring her little quips; she was just being silly Whitney. But her weird behavior continued. Throughout our little tour, her purse references continued: "Boy, my purse is so heavy today." Again, I ignored her comments.

"And over here is the master bedroom," I'd say, and then we'd keep moving through the house. I was becoming a professional *ignore-her*.

At the end of the walk-through, we stepped out on the back deck. She reached in her purse and handed me an envelope.

"Here. Open this." She grinned from ear to ear as she spoke the words. "I told you my purse was heavy."

"What's in it?"

"Just open it."

I was stunned. Inside the envelope was a check for $50,000—the exact amount I needed to make the balance of the down payment. Now the bank had no excuse not to give me the loan.

If you've ever owned a home, you can relate to the feeling you get when things fall into place for your first place. I had started to believe that this first home was going to have to wait a bit longer.

Not so. Whitney wouldn't allow it.

I was dumbfounded.

I just stood there, speechless. And Whitney kept grinning.

And then it all made sense. In my head I was hearing the words she'd repeated as we walked through the house: "Oh, this looks like my brother's house. . . . This looks like something in my brother's

house." And in that moment, what was "looking like my brother's house" became *my* house! She had been talking about *me*!

The look on her face as she walked toward me with arms wide open is etched into my memory.

"I love you, brother," she said, wrapping me in a huge hug. It was The Pact at work, but in a totally unexpected way.

I looked her in the eyes and said, "I promise you, sis, I am going to pay you back."

"Whatever. I'm hungry. Let's go eat."

And we did.

<center>⋯⋄⋯</center>

I grew up in a time when your word still meant something. It was, in fact, your bond. I still think your word is all you really have. You can ask any of my friends; if I give you my word, then I'm going to do whatever I need to do to keep that promise.

I kept my promise. Eventually, I was able to send Whitney an initial installment of $25,000. It was one way I could honor The Pact.

When Whitney's accountant told her about the money, she called me.

"Hello, my brother."

"Hey, what's up?"

"Well, I had to call because I just heard that you sent me $25,000."

"Yeah, that's the first installment on the money I owe you."

She didn't respond. There was only silence on her end. Then, in a soft voice she said, "Wow, I wasn't looking for you to do that."

"What do you mean? I said I was going to pay you back."

"Yeah, I know, but so many people say that and never do it. I've gotten used to people asking for things and never giving back."

Upon hearing her words, I realized the realities that come with being a person like Whitney—a person who isn't just well-off financially but downright rich . . . and rich for the world to see. Whitney went on to tell me about the good and the bad that came along with all her wealth—from the letters from absolute strangers asking for financial help to the friends wanting something, and even family tensions. One letter she shared with me was from a woman in Florida. "I want to show you something," Whitney told me. "Let me read this to you, because this is how people are."

The letter said this woman needed help. Her heat was turned off; she didn't have any money to turn it on . . . But then Whitney told me the date—it was summertime!

"BeBe, this letter is from Miami, Florida!" Whitney exclaimed. "I was writing a check to this woman, and if I hadn't read the whole letter, I would have sent it! Needs the heat turned on in summer? In Miami? C'mon!"

Opening up about the intricacies of her situation, she confessed: "No matter how much you do with your wealth, no matter how much you try to help others, no matter how many funds you set up, it's never enough. There's always someone ready to criticize what you do or don't do. It's incessant to the point it wears you down and wears you out."

"Whitney, I understand what you're saying," I replied, "but I'm not one of those people."

Her response in this situation helped me understand how important it was for her to not only have people to talk to, but people who weren't out to get something from her. This was an important lesson

for both of us. For me, I began to understand my role in her life: I needed to be the type of friend she would have even if she were not Whitney Houston. And in that kind of relationship, there's a healthy amount of freedom to be yourself no matter what, and to know that you're safe in doing so.

It also meant there was no unhealthy pressure between us. Whitney was an adult; she didn't need a babysitter. Whitney went off and did her Whitney things. But what she needed from me was a person with whom she could pick up where we left off. She needed to feel like I was always there for her and would be a safe haven. And that's where The Pact came in for her: our conversations would be kept safe with each other.

That's also why, in this book, you're getting my Whitney highlights and insights, but the exclusively private and personal stuff stays where it's always been: in a safe place, honoring The Pact . . . honoring the family.

<div align="center">⋅❖⋅</div>

It's hard to convey how your life turns upside-down when you experience the fame that Whitney did. But that high-intensity fame made our Pact even stronger. Let me give you another example of how Whitney interpreted The Pact, and how her perspective of family shaped so much of our friendship. It's also one of those stories that allows me to trade in my grief for laughter—a story that allows me to remember the Whitney I knew "backstage."

Whitney was in London for a series of concerts—I believe it was in 1987 or 1988—and in speaking to her on the phone from my home in Nashville, she kept asking, "BeBe, please come hang out with us.

Come see me." I said yes, like I usually did, because even though she traveled the world and had this incredible vocal gift, she always wanted to be surrounded by friends on stage and, most importantly, when she came off the stage. This was important, because when Whitney was entering the world of celebrity, her mother warned her that life would be lonely. Cissy was right, but Whitney fought that loneliness with everything in her power. London was a testimony to that fight.

I had a writing session scheduled in Brazil a week after Whitney's London shows, so I worked it out where I could go visit her in London first and then proceed to São Paulo to fulfill my commitment. So, it was on.

I met up with her and some of the crew at a restaurant after that evening's concert was over. When I walked in, she greeted me like she always did: "Hey, my brother! Everybody, my brother is here." She and I embraced, and whoever was sitting next to her surrendered their seat.

For the next several hours, until the sun started to peek its head over the horizon, we laughed and talked and talked. Upon realizing the time, I looked at her and said, "Good night! Better yet, good morning! I'm going to bed." Whitney, who was a night owl (actually, we called her a vampire because she loved the night and didn't come alive until after 11 pm) groaned and complained, but accepted my departure and let me go on to my room.

The next day she and I had brunch at the hotel right at the time they were serving high tea. As I've mentioned, church was part of Whitney's core being—and so was her faith. She just loved church. So even while enjoying a simple brunch and tea, it only took a word for her to bring God into the conversation. With laughter on her mind, she said, "You know why we're really having high tea?"

I knew where she was going with this, but played along anyway. "Why?"

"Because we are having tea with Jesus, and he is high and lifted up!"

I chuckled and said, "Amen!"

After our meal, she and her team readied to leave. They were leaving London and catching the train to Paris for some concerts there. As she prepared to leave, I knew what she was going to ask, and I had my response ready. She didn't let me down.

She looked at me and said, "I know you love me . . ."

"Yes, I do. And my answer is no!"

She begged and pleaded and proceeded to tell me the reason I couldn't say no and that I had to come. I just *had* to. She could be such a little girl when she wanted to be.

I said, "You know, you're wrong for trying to make me feel bad for coming all the way to London to visit you. And it's not going to work."

Right.

Well, it *did* work. My bags were already packed. I tagged along to Paris.

Whitney slept the entire train ride. That's what she did to revive herself. She was a vampire, remember? She needed to sleep during the traveling hours so she'd be ready for the late-night hangs.

After arriving in Paris, Whitney and I went shopping with Whitney's longtime assistant, Robyn Crawford. Whitney loved shopping almost as much as she loved singing. It was right around the time of my birthday—I remember because that's what she and Robyn used to somehow convince me to purchase a black leather coat that was *way* out of my price range. It was the most expensive coat

I'd ever bought. To this day, it is still the most expensive coat I've ever bought.

Whitney and Robyn kept telling me, "Don't think about the price, BeBe. You work hard; you're worth it." Well, they won. It made me sick to my stomach to spend so much money on a stupid jacket. But really, it's still in my closet, and I still wear it, and you know what? They were right. I was worth it.

Whitney had two concerts in Paris. I stayed for the first one, but on the day of the second one I left from the venue before Whitney arrived. I said my good-byes and told Robyn to give Whitney a good-bye hug from me and that I'd see her soon. But my Paris exit wasn't as smooth as I thought it would be.

When I arrived at the airport I found out that the travel requirements for Brazil had changed since my last visit. I now needed a passport *and* a visa. I didn't have a visa. I asked the check-in clerk to call the airlines for help. But that didn't work. To make matters worse, the airline agents were extremely unfriendly and acted like they had no time to help me. I began to get angry.

Understand, I come from a family where cursing was not allowed. Ever. So profanity was never part of my vocabulary, until that night.

I was so livid, I lost control for the briefest of moments, swearing like a sailor at the airline agents. As soon as the words flew out of my mouth, I stood paralyzed. I so stunned myself with my angry swearing that I immediately asked the agent for forgiveness and then went straight to the phone and called my brother Ronald.

After I told him what had transpired, he laughed and said, "Did you ask God to forgive you?"

"Yes," I said.

"Well, then, it's okay now. You may not be able to win the agent over, but you're fine."

I collected my things and headed back to the venue where Whitney was performing. It seemed I was staying for concert number two after all.

She was already on stage and the band had just started leading into one of my favorite Whitney songs ("How Will I Know?"). I headed down to the gated area between the stage and the audience and stood to the right of the stage. Whitney was on the opposite side, with no clue I was there.

She sang the first few phrases and then turned in my direction and saw me standing there. Without missing a beat, she sang the words, "There's a boy I know, he's the one I dream of . . . *missed your plane, missed your plane . . .* Looks into my eyes, takes me to the clouds above."

She was so smooth, the enthusiastic audience in that sold-out venue had no idea that she was having a conversation with me during that performance. If I didn't know better, I'd think she tried to rush through all her hits in the set so she could discover just exactly what caused me to "miss my plane, miss my plane."

As soon as the standing ovations and last good-byes to the crowd were over, she sought me out. "What happened?" she asked.

I was still stunned by my encounter with the flight agent—my flurry of abusive language. So I plopped down next to her on a couch and told her what happened with my flight and how heated I got. I never mentioned anything about using profanity, but she looked at me and asked, "Did you swear?"

"Um, yes."

She lit up, wanting to know every detail. This was a big deal to her because since the beginning of our relationship, she had never heard CeCe or me use any profanity. She even asked us once, "Why doesn't anyone in your family curse?" When she asked that question, I realized how she absorbed everything, even the slightest of differences in our behavior. She never missed anything.

Well, she promised not to say a word to anyone and begged me to re-enact the whole scene. So, since I was stuck there for two more days, I entertained her for free. And oh, was she entertained.

"She lived right around the corner from me.
Every time Ms. Whitney saw me,
she would go 'Ruff Ruff Ruff.'"

❖

BOW WOW

CHAPTER **FIVE**

Crazy Whitney

You broke, right? And I'm rich, right? So I can buy whatever I want for y'all.

Whitney, being CRAZY

୶ଈଡ଼

One of the times during filming of *The Preacher's Wife* when Whitney was staying in New York for a few weeks, she called and tried to convince me to hang out. She knew I was already in New York, and that I had plans, but in typical Whitney fashion, she asked anyway.

"BeBe, won't you stop by?"

Basically, she was lonely and wanted some company.

"Whitney, you know I have things going on, and then afterwards I'm going to the hotel because I'm tired and I . . ."

"Just come by here. Please. C'mon."

So I obliged. Whitney was one of those people who would continue asking until you broke. And to make matters worse, she knew me pretty well. She knew my breaking point.

I showed up on the set of *The Preacher's Wife* and was meeting people and talking with Whitney. At one point, Whitney went off to do something and Penny Marshall, the director, approached me.

"Hey, BeBe," she said. "I was thinking during the break how great it would be if you would sing Whitney's song for her—you know, the one from this scene, 'I Believe in You and Me.'"

I saw Whitney enter the set and I pointed at her and said, "Oh . . . no. You see, I'm just here for *that* girl over there. And besides, I don't even know the lyrics to that one."

Penny smiled and said, "Oh, come on; it will be fine. It's just us. It'll be fun."

"Sorry, Penny. I'm just gonna hang out and observe, ya know?"

Penny gave up. After the segment ended, I walked over to Whitney. "Listen, Penny asked me to sing your song for you. And you know I ain't doing nothing of the sort."

Whitney just stared at me.

"I need you to tell her that *you* invited me over here to hang with you—for some company," I urged. "I didn't come here to sing. I ain't singin'."

At that moment Penny walked up again and said, "Hey, Whitney, I was just telling BeBe how great it would be if he would sing your song—just for fun, just to encourage everyone a bit. What do you think?"

I looked at Whitney, fully expecting her to tell Penny how bad that idea was. Whitney looked at me, leaning her head and raising

her eyebrows—that mischievous look—then glanced over at Penny and back at me. She was milking the moment.

"Oh, Penny, I think that's a *great* idea!" she exclaimed.

My eyes about bugged out of my head. Whitney had just sold me out.

"Really?" replied Penny.

"Yeah, of course. BeBe, c'mon; it'll be great. I'll feed you the words. We'll do it just for fun," Whitney said.

We wrangled around for a few minutes, but it was pointless. I finally relented and agreed to sing "I Believe in You and Me" as long as Whitney did it with me. And, I had one more stipulation: no cameras. "I don't want this thing recorded," I told them. "It's just for fun."

Penny agreed and assured me that there would be no cameras. So, we sang the song. It was all rather harmless and it *was* fun, I have to admit. In fact, my entire time on the set was great.

Well, weeks later, I was meeting my friend Pauletta Washington— wife of Whitney's costar, Denzel, in *The Preacher's Wife*—for spin class at a local gym. When I arrived at the gym, she approached me and said, "Hey, BeBe, you were great last night at the ball. I think it's great what you did, singing that song with Whitney on the film set."

I had no idea what she was talking about.

"What ball?" In my head, I was saying, *Because I* know *no one saw me singing at no ball, because Whitney and Penny both said the cameras weren't rolling.*

"Whitney's song, 'I Believe In You and Me,' from *The Preacher's Wife.*"

She replied as if I was playing games with her. But I wasn't playing a game. This was news to me! Apparently, not only had cameras been rolling but the footage had been shown to a group of people.

"Pauletta, where did you hear me sing that song with Whitney?"

"Denzel and I were at the Carousel Ball in LA last night. We saw the video there."

The Carousel Ball, from what I knew, was a major event. So you can imagine my shock. I was trying to sort it out in my brain: *There's no way those people saw a video of me singing with Whitney. There's no way, because Penny assured me that the cameras were not rolling.*

I called Whitney to ask her what was going on. You can imagine the response I received: "I don't know what you're talking about, BeBe." I could almost hear her internal giggling through the phone. Then, as she came clean, I found out that at first, she didn't know the cameras were rolling either. So, Penny got us both! But now Whitney was reveling in the fact that she and Penny got *me*. Luckily, Penny still has a copy of this video and she made me a copy. ◼ **GO TO TheWhitneyIKnewVideos.com TO VIEW THIS AND OTHER BONUS MATERIAL.**

You can't pull stories like this from the Internet. You *live* them. They're the kind of stories you have of your friends, the stories that you laugh about over dinner or on the back deck when you're hanging out.

Whitney's mind was crazy. Not crazy in a negative way. Crazy in a zest-for-life kind of way. It was in her DNA to push things to the limit with regard to our friendship. And by *push things*, I mean, have fun with them. If she knew your buttons, she'd push them.

◆◆◆

When you lose someone close, eventually you stop saying good-bye. Saying good-bye is the *hurt*; it's the process of letting them

go. If we're honest, it can be a selfish time for the one who remains. We want the ones we've lost for ourselves. We want them back in our lives because they enriched us so much. But there's another level you eventually reach. It's the level where you've said good-bye for the final time and you're content to laugh through your fondest memories.

I'm at that point in the good-bye process with my brother Ronald. I think there will always be a tinge of hurt and "Oh, I miss you, brother." But Ronald's memory now gives me so much joy—joy that I had him in my life, and joy in receiving the great life he gave to us all.

I'm not there yet with Whitney. I can't escape seeing the tabloids. Someone's constantly drumming up some ridiculous concoction of a story, marring her name even in death. It's bad enough that we as a culture brutalize celebrities—who we seem to forget are human beings—by spreading lies and distorting truths about them in the media when they're alive. It's a different ballgame when we do that after they die.

I just want it to stop. I want to erase the unflattering pictures and the false articles about her and hoist the banner of truth that is Whitney's life in totality. Like Aretha urged people about Whitney after her death: "Remember the hits. Forget the misses." Why can't we revel in someone's actual life instead of the shadows of the truth? Why can't we respect the family who's lost one of their own, and let them grieve in private or go public as they will? Why can't we grow up?

For me, the time will come when I move from hurt to sweet memory. But I do wonder about those who were closer to Whitney than I was. It's hard enough to lose a mother and a daughter and a sister. That loss is compounded, however, when a culture that raised her up as their princess won't let her pass into the peace that passeth

understanding because they want to gossip about the nuances of her death.

But my disdain for the popular media does not overshadow her memory—the Crazy Whitney still lives in my mind. That memory helps me through the hurt and is helping me move into the peaceful good-bye. It helped me get through her funeral as well.

I told myself that I wasn't going to say anything or even sing at Whitney's funeral because I didn't want to cry in front of everyone. But I didn't really mind. Now that I look back on the event, I realize I said that more for me at the time. Still, before I even reached the pulpit and the music began, I broke down and started to cry. So I turned right back around and looked at CeCe and said, "Get up. You're coming up with me." Which is the way it should have been, because she and Whitney and I spent so much time together.

In that moment, what kept coming to my mind was the fact that we talk about Whitney's voice and we talk about her talent, and we'd already established that it was a beautiful and unique gift. I could have easily echoed the sentiments of so many who loved her voice, but on this occasion, that just wouldn't do.

"What I'm going to miss most of all is Crazy Whitney," I said as memories flooded my mind. Like the one when me, CeCe, Robyn, Robert Matta, and Whitney went to see *Prince of Tides*, starring Barbra Streisand and Nick Nolte. Whitney always wanted to know why I never liked to go to movies with her. Well, because she talked so much. She'd just talk and talk, all the way through, commenting on everything. It drove me crazy! But the four of us went with her that night. I sat behind her because I actually wanted to hear what was being said. Whitney sat in front of me with CeCe and Robyn. I watched Whitney talk CeCe's ear off; she couldn't help herself.

Near the end of the movie the woman sitting in front of Whitney turned around and said emphatically, "Can you just shut up! Please! Just shut up!" and then turned around and sat back down.

I watched Whitney lean up to whisper something in her ear, and the whole time I'm praying that "Jersey Whitney" doesn't come out. After Whitney whispered in her ear, the woman turned around again and said, "Just shut up! You're talking too much!"

"Lord, keep 'Jersey Whitney' away. Save this poor woman."

For a moment, it seemed like my prayers were getting through. But then Whitney leaned up again, grabbed the woman's blond ponytail, and said, "You shouldn't be so rude!" Then she pushed her head forward by the ponytail!

Robyn said, "BeBe, get her outta here! Go!" because the woman stood up and screamed, and her boyfriend stood up like he was getting ready to fight.

Robert and I grabbed Whitney and we bolted from the theater. CeCe and Robyn caught up, and we ran for the car. Once we piled into the car, trying to grab our breath, Whitney blurted, "That was so much fun!" grinning from ear to ear.

"Fun? That wasn't fun!" I said. "My heart is pounding out of my chest!"

That was the last movie I went to with Whitney until *The Bodyguard* released.

Many years later, I felt like we were in a movie—because it couldn't possibly be real. But there CeCe and I were at New Hope Baptist Church the night before Whitney's funeral, making preparations. I turned to her and said, "CeCe, if there's anything I want to share, it's what I'm going to miss most of all: that Whitney who was plumb out of her mind in terms of how loyal she was to us as a friend."

CeCe agreed, so when it was my turn to share, I spoke of the Crazy Whitney I knew: "CeCe and I were making plans for our first headlining tour when Whitney called. The story goes like this."

<p style="text-align:center">❖</p>

"Y'all need to come on over."

"What?"

"Yeah, come on over; I need to talk to you."

Remember—and I was always reminding Whitney of this fact—we lived in Nashville and she lived in New Jersey. So for us to "come on over" meant booking a plane ticket. It wasn't like we just lived next door, though that's how she acted.

But we booked a flight and landed in New Jersey. Once we got to her house, we somehow, amid the small talk, ended up in her closet. I'm not sure how it happened, but that was Whitney. Besides, it's not like we were hurting for room in her closet—her closet was as big as the sanctuary we gathered in to remember her. So, not to worry, we weren't crowded.

Sitting there among the dresses and shoes, she let us in on her master plan.

"So, here's what we're going to do."

"What do you mean, 'What we're going to do?'" I asked.

"Well, I went ahead and I had some uniforms made."

"What? What uniforms? What you talking about, girl?"

"I ordered the dresses for the background girls."

CeCe just looked at me.

"Yeah, yeah, they're cream. And I got the band their uniforms—their shirts and pants and all that. And BeBe, I got you a suit. It's

cream too. And CeCe, I got you a melon dress made. Oh, and I got me a green one." She had a green one made, *for herself*!

"Hold on, hold on. What you mean, you made yourself a green one?" I asked.

"BeBe, this is for *our* headlining tour—for the tour, BeBe."

Now, as I was telling this story at her funeral, I remembered Clive [Davis] was in attendance. And I recalled that Clive was not happy that Whitney was heading out on the road with us. But Whitney was into her plan and was excited to be telling us.

I broke in and said, "Whitney, you can't be doing that. No one told you to do that. This is not a materialistic relationship—you don't have to do any of this."

"Okay, okay, I know, BeBe. But let me ask you something. You my brother and sister, right?"

CeCe and I both responded, "Yeah, of course."

"And I'm your sister right?"

"Yeah. You're our sister."

"And we love each other, right?"

"Yes," we said, "we love each other."

Then Whitney said . . . and this is what I'm really going to miss . . . she said, "And y'all broke, right?"

Oh my! We just stared at her. *Should we laugh? What should we say?*

"And I'm rich, right?" she continued.

No hesitation there, "Yeah, . . ."

"So I can buy whatever I want for y'all."

Bottom line, we were about to open our first major headlining tour in Los Angeles. The smart thing, the normal thing, for a tour like ours was to start in a small city, work out the kinks, and then move to

a major market. But we were headed to LA, and Whitney knew that, and I think she was a bit nervous for us. She wanted it to be perfect; she wanted to help make it perfect.

Now, that is the Whitney I am going to miss—the true Whitney.

⸺❖⸺

After I told that story, CeCe tried to escape the platform, but I didn't let her. She needed to be there, and I needed her support—and so she stayed while I tried to make it through the song I wrote for my brother Ronald when he passed. ◼ **GO TO TheWhitneyIKnew Videos.com TO VIEW THIS AND OTHER BONUS MATERIAL.**

Family had gathered on that day of days, that time when she lay quiet—her voice no longer audible. At that moment, all the thoughts and feelings of Ronald and Whitney intermingled, and I hurt deeply for my *family*. But in my mind, Whitney's voice persisted. That thing she used to always say to me before I sang, I could hear her saying to me on that day, in the Jersey girl's home church: "Don't embarrass me, brother. Get it together."

And so the music began, and the words came out:

With tears on my pillow
Refusing to let go
When I heard you left here
Felt alone on a playground
I'm lost, in your hometown
Since you left here

They say time makes it better
But in time, I'll see you later
We'll be together, a long time, forever
When I leave here

But I'll miss your wit
I'll miss your charm
Just want to hold you, in my arms
My heart's sad and blue
You have no clue
How I'll miss you

I'll miss your voice
When you would call
I'll miss your smile
Most of all
Just us two, with nowhere to go
And nothing to do
I'm gonna miss you

I take simple precautions
I think of you often
Since you left here
Life a bit harder
I love a lot smarter
Since you left here
The days that I can't take it
I'll learn how to make it
With Jesus and memories

Helps me and keeps me
Since you left here

Oh, but I'll miss your wit
Oh, I'll miss your charm
Just want to hold you in my arms
My heart is blue
Cause you have no clue
How I'll miss you
I'll miss her voice
When she would call
I'll miss her smile
Most of all
Just us two, with nowhere to go
And nothing to do
I'm gonna miss you

So, Lord, just hold her
Hold her in your arms
Rock her in your arms
I'll miss her voice
I'll miss her smile
Most of all
Just us two, with nowhere to go
And nothing to do
I'm gonna miss you

There'll be tears on my pillow
It's hard to just let go

When she left here
But what I know for sure
It was a great celebration
And Jesus was waiting
When she left here

("I Really Miss You"/BeBe Winans)

···⋄···

The more I play these stories over in my mind, the more I keep remembering. Like the night CeCe and I sang on *The Arsenio Hall Show*. Whitney had called earlier that day and found out we were going to be on: "I'm coming over there," she said.

Sure enough, when we arrived at the studio, she was there. And during the performance, she stood backstage and watched her friends sing. CeCe sang "Don't Cry For Me"; I sang backup with the girls. CeCe nailed it.

When she finished, Arsenio ran up, grabbed CeCe's arm, announced her name, and did all the things a host does. And who do you think ran out with Arsenio?

Whitney.

That girl ran out with the host of the show and gave CeCe a huge hug on national television. Then she looked back at me and the girls and said, "That was perfect, y'all." Who else could just show up on the set of a major network and then run out on stage with the host to congratulate her friends? Only Whitney.

After a while, we came to expect these "drop-ins." In fact, it wasn't uncommon for Whitney to drop in on our tours. Sometimes

she'd stay for two days, sometimes a week. We kept a bunk ready for her on our bus, just in case.

One thing that makes me smile even today is the time all three of us were on the bus headed to our next concert. Whitney was hungry and wanted to stop and get something to eat." Now, CeCe and I were early in our touring career, and there were many things we didn't know—like what you should expect from your bus driver and all that jazz. But Whitney educated us.

"We'd love to stop," I said, "but the bus driver won't let us. He said he doesn't take breaks between tour stops."

Whitney became indignant. "He *told* you that he won't stop?"

She stood up and marched to the front of the bus and confronted the guy. "Are you telling them that you don't take breaks between tour stops? No, no, no! You're going to stop at the next place that you see that has a restaurant."

The two of them exchanged words, and Whitney returned to the back of the bus with us. "Okay, we're stopping. I can't believe that," she muttered. Then she went on to make a laundry list of the things the bus driver was supposed to do as a paid employee of the tour.

"Does he make your beds?"

"No, we make our beds."

"What? He's supposed to make up the beds and wash the sheets . . ."

In mid-sentence she stood up again and marched to the front of the bus. "And when we get out to get something to eat, you need to make up all these beds."

Boy, were we glad she was along on *that* tour! That bus driver was getting away with murder, according to Whitney. She schooled

us on touring protocols, empowered us with knowledge—empowered us with *herself*.

<center>⁙</center>

When Whitney decided to take a break at the height of her career, there was no stopping her. She took some time to hang out with CeCe and me, even though it meant defying her record label's president, Clive Davis, and all the other executives. So be it. It was important to her to keep it real.

Now, every great singer—including Whitney—started by singing backup for someone. It's a great way to hone your skills. Clearly, though, Whitney didn't need honing at that point. The real reason she came to tour with us was to have fun—to feel not like "Whitney Houston." She did it to step out of the spotlight and into our lives, where she could be a little more at ease. When she was around my family, the weight of her fame seemed to lift a bit. She could slip into the background and sing for singing's sake.

Still, when people came to our concerts and then realized that Whitney Houston was singing behind us, all the attention shifted. The cameras went straight for Whitney. CeCe and I would crack up.

When we were all together, we enjoyed every moment. There were no masks to wear; it was just friends singing their favorite songs and having a good time. If you watch Whitney's and CeCe's performance at the 1996 Grammy Awards, you'll see them bringing down the house. You'll also catch a glimpse of two sisters ushering in a worship service right there at the Grammys. ◾ **GO TO TheWhitneyIKnewVideos.com TO VIEW THIS AND OTHER BONUS MATERIAL.**

Whitney showed up so many times to sing with us that we started keeping an extra microphone on set, just in case she burst onto the stage. I remember one time Whitney called me because she was in LA at the same time we were. CeCe, Whitney, and I had each been nominated for an Image Award. Whitney found out that CeCe and I were leaving the awards early because we had two concerts.

"What time y'all singing tonight?"

"At 9 and at 10:30. Why?

"Okay, I can't make the first one, but I'm going to come out for the second show."

And she did come out. She arrived at 10:25 pm. And before the evening was over, she was on stage with us, singing.

From then on, I always had to remind her that she was Whitney Houston and that she had her own band. She didn't care. She loved singing with us; she loved being with us. And we loved it too.

One final tidbit about how crazy Whitney could be when it came to CeCe's and my music. One night on tour in Russia, I was relaxing in my hotel room when the phone rang. It was Whitney.

"BeBe, listen. Listen hard . . . and just obey me."

"What? Why are you calling me?"

"Just shut up and listen. CeCe is probably coming to your room right now; I just got off the phone with her. She said she's going home. She's homesick and wants to be with her kids. But I'm telling you, don't say nothing except 'yes' and 'okay.' If she leaves, I'll fly to Russia and finish the tour."

Whitney started giving me all kinds of information: she had booked her flight; she was on her way; *she* would finish the tour. By the time she finished telling me all this, I heard a knock on my door.

"Hold on, Whitney; someone's at the door."

It was CeCe. She was crying. "I'm going home. I'm not doing this . . ."

CeCe rambled on and on . . . She was a mess. "I just talked to Whitney. She said she'll finish the tour for me. Okay?"

I remembered what Whitney said: "Just say 'yes' and 'okay.'"

And that's what I did.

After CeCe left, I picked up the phone and Whitney asked, "Was that her?"

"Yeah, that was the Reluctant Star. She said she's going home."

"Okay, now if she doesn't cool off and change her mind, I'll be on a plane and will finish it for her."

Luckily, CeCe changed her mind and stayed, and Whitney was off the hook.

Would Whitney really have dropped everything to fill in for CeCe? Yes. When she called, she already had her flight reservation. Did Whitney have a full month to give so we could finish the tour? No. But she would have made time. That much I know.

She was crazy.

"She knew deep down that in the final analysis,
it was always between her and God.
It was never between her and the world."

❖

PAT HOUSTON

Whitney, Jesus Loves You

They are weak, but He is strong.

Lyrics to the song that resonated in Whitney's soul

❧

The common denominator between Whitney and myself—and CeCe and the rest of my family—was a love for God and for gospel music. She was most happy in that setting. In fact, when CeCe first heard Whitney sing, she didn't know who she was, but like me, she knew she had to be a gospel singer because Whitney was belting out some commercial jingle "like she'd been saved!" is how CeCe put it to *People* magazine back in July 1989. Interestingly enough, the first time Whitney heard CeCe sing, which was on our self-titled album in 1987, she became an instant fan. "We come from

the same place," Whitney told *People*. And she wasn't talking New Jersey. She was talking about the church.

With that kind of connection, is it any wonder that we became family? Our bond made us want to work together too. So before CeCe and I headed into the studio to record tracks for our *Heaven* album, which released in 1988, Whitney and CeCe and I had agreed that we'd record a song together specifically for this project. We were so excited about this, you'd have thought we were eight-year-olds headed to Disneyland.

One thing you should know about me: I love sharing the microphone, the stage, and the studio with great talent. Now put yourself in my shoes. Imagine yourself as a singer, and the person that many consider the finest singer in the world at the time—and certainly the top-selling female artist at that time—can't wait to join you on your record.

I can't even write the correct words to express the elation I felt.

When our record company—Capitol Records—caught wind that Whitney was going to record with us, they could hardly contain themselves. Understandably, though, Whitney's label—Arista Records—didn't like the idea of sharing their global phenomenon with anyone. So, like many conversations with Whitney, she told me to expect a call from her lawyer about the "cans and cannots" of the recording.

Soon after she and I hung up, I received a call from her rep. He was kind but brief. Our conversation went something like this:

"Hello, Mr. Winans. I know you were expecting my call, and I hate to tell you this, but even though Whitney said she could record with you and your sister, I'm going to have to be the bearer of bad news."

He had my attention.

"After reviewing her contract with Arista, we've determined that she cannot participate in the recording at this time. I hope you understand."

"Of course. I understand."

I was disappointed but not at all surprised. That's the reality of the industry.

About ten minutes later, Whitney called back, all excited—just checking to make sure that her rep had phoned and that everything was okay. The excitement in her voice tipped me off to the fact that she had no idea the recording was off the table. I decided to be cordial and proceeded to tell her that CeCe and I understood her label's position; perhaps in the future we could try again.

"What are you talking about?" she asked.

I started explaining my conversation with her rep, but she cut me off. "Boy, hang up this phone. They're going to call you right back."

I don't know what she said to them, but the guy sure called back singing a different tune. And the brief lyrics to this tune sounded something like this:

"Hello, Mr. Winans. I'm just calling back to tell you all is well, and that Whitney will be able to do that recording with you and your sister after all—whenever you're ready. Okay?"

"Oh, okay."

"Yes, sir. Have a good day." *Click.*

After we hung up, I counted down: five, four, three, two, one. *Ring, ring.*

Whitney was back on the line.

"*What* did you say to them?"

All I remember of her response was laughter.

It was on. And when we all got into the studio (we actually recorded two songs for that album, "Celebrate New Life" and "Hold Up the Light"), we were like kids on a playground—we didn't want to leave. ◼ GO TO TheWhitneyIKnewVideos.com TO VIEW THIS AND OTHER BONUS MATERIAL.

Some of the pictures from that studio session hang in my home office. Though it's a faraway memory now twenty-five years old, it feels like it was yesterday. I remember the white shirt and jeans Whitney wore and her hairstyle; I even remember the perfume she was wearing. It was a blessed time.

But what I remember most of all were the moments she'd open her mouth and let those notes fly. She sang on a song that my friend Percy Bady and I wrote. It was as if heaven had stepped into the room. And as we sang to our hearts' content, I could feel that family bond rise and grow stronger. The bond was more than blood, it was spirit. Sure, we were "family," but we were more than that. We were brothers and sisters in Jesus. Heaven came down that day and painted our time with joy and wonder, grace and blessing.

There was no jealousy or ego or spite between us. There was only song and mutual admiration and an uncommon joy. We loved each other and we loved the God we proclaimed. That studio was like our own little sanctuary, and we were free to praise and worship as we saw fit. We sang and sang and sang . . . We were not just any little children singing our favorite songs; we were God's children reveling in his glory, and we bathed ourselves in it.

<div align="center">⬩⬩⬩</div>

"Thank you, Lord."

If you ever listened to Whitney perform live, you'd inevitably hear her insert this tiny prayer of thanksgiving into most any song. It's almost comical, because at times she'd insert it where it really didn't belong. Yet she remained undeterred by whether or not something "belonged."

Jesus was always on her mind.

Yes, she loved Jesus. And this fact was never more evident than when she called to tell me that "Jesus Loves Me"—Anna Bartlett Warner's little poem that so many children grew up singing in church—was going on *The Bodyguard* soundtrack as the B-side single. This was a triumphant moment for her and for us, as my brother-in-law Cedric Caldwell and I had arranged, produced, and written an additional verse for the song. It was making the cut! Whitney's excitement in telling us was unbridled.

During the height of her career, she'd unabashedly sing "Jesus Loves Me" at her concerts. I suppose some people chalked that up to mere patronization—assuming she was simply doing a shout-out to her upbringing. But I assure you, the Jesus in Whitney's life was the same Jesus in my life. And she loved to sing about him.

When Whitney sang "Jesus Loves Me" in concert—or any gospel song for that matter—it was not a mere shout-out. It was Whitney baring her soul. It was Whitney harking back to the Rock from which she was hewn and resting in the peace she gained from that Rock.

It's the place she always wanted to be.

When you listen to Whitney's 2009 interview with Oprah, she references that place of peace. By the time her marriage had fallen apart and things were off the rails with her drug abuse, she knew

she had steered off course. But she also understood that there was a divine grace that longed to help her get back on course.

I remember the day Whitney made a public faith proclamation. CeCe and I were in a Nashville church with her. The preacher gave an altar call—the part of the service where he invites folks in the audience to make a commitment to follow Jesus. Without either of us knowing or being aware of what she was doing, Whitney stepped out from her seat, walked to the front of the sanctuary, and gave her life to the Lord that night.

Her boldness knew no bounds, for she was "Whitney" at this time—someone so well-known that, really, a person didn't even have to say her last name. This wasn't pre-stardom, I-knew-you-when stuff.

What about her image? What about the tabloids and the rumors? None of that mattered to her at that moment. Though she was raised in the church, she had never professed her faith in Jesus as an adult. Seeing her up front at that Nashville church, praying with the pastor—that was one of the first memories that sprung into my mind when she left us. I can see her now up at that altar, kneeling and praying.

Her faith was real to her. She took it seriously. And lyrics like the ones from my brother Marvin's song "In Return" were what Whitney would use in the gospel section of her set to tell her story. ■ GO TO TheWhitneyIKnewVideos.com TO VIEW THIS AND OTHER BONUS MATERIAL.

All I had to give was a broken heart, all torn apart
All I had to give was an empty hope and promises
But in return, he gave me joy that could never be told

And in return he gave me love that is more precious
 than any gold
So whatever you have to give, you don't have to be ashamed
Just come as you are, and present it in Jesus' name
For in return of a torn life, he'll give you life abundantly
And in return of a raging storm, the Lord will calm the seas . . .
And if you were like me, you didn't have a lot of gold
Position or money. You didn't own wealth untold
But Lord, I'm glad you didn't look on the things that I had
But you looked on the things that you were able to give me

The beauty of lyrics like these is that they don't just tell Whitney's story—they describe my story and yours, if we let them.

Whitney sang "In Return" as far back as 1991, never suspecting that only two years later, in 1993, her world would explode yet again with the release of *The Bodyguard* soundtrack and movie. The soundtrack—one of the ten best-selling albums of all time at her passing—included the single "I Will Always Love You," which to this day is the top-selling US single of all time. It catapulted someone who was already an international superstar into another stratosphere altogether. Her life became the property of the world and her voice America's treasure. When she sang, "And in the midst of a raging storm, the Lord will calm the seas," there was no way she could've known that her life would become a raging storm and she would be lost on those waters for a time.

The "Jesus Loves Me" single, which was on that record-breaking *Bodyguard* album, released in 1993. Fittingly, we recorded that song in Whitney's studio, which was located on the lower level of her home, down the hall from her trophy room. Since the studio was in

full use, audio techs and other hired personnel were in and out of the house—though they only had access to that one area. In order to have free roam of the house, you had to have a special pass. Since I held one of those passes, I was the one who always went upstairs to get Whitney whenever we needed her.

We'd lay down some tracks, and she might call me on the phone from upstairs: "Hey, how's it going? Everything alright? You need anything?"

"Everything's fine, but we'll be needing you soon to lay down some vocals."

Just to get me going a bit, Whitney would be coy. "I ain't coming down there now . . . I've got so much to do up here."

"Girl, you better come on down when I call you down, or I'll come up there and get you," I'd say.

Eventually she would relent and get down to business.

Whitney was fast in the studio, but during our sessions for "Jesus Loves Me," I pushed her a little more than she was used to. It's different when a vocalist produces a vocalist. A vocalist can push a bit more than a music producer who doesn't sing, knowing that there might be something just beyond the singer's "comfort zone."

Whitney enjoyed the rigor of the studio and the fact that I made her work a little harder. And, because we were in *her* studio, she couldn't give me any excuses. We worked, and she loved it.

One of my favorite things about Whitney was that she had no real pretenses in the studio. She didn't need candles lit or something to set the mood. Her voice brought the mood, and her love for singing was her inspiration.

If she had any studio quirks at all, it was that she used any excuse

to talk. If she wasn't giving me a hard time, she was chit-chatting and cutting up. I'd get her focused again, then she'd start talking—about the song, about an upcoming concert, about going out and getting something to eat. All she needed was a window of opportunity, and she'd rev up again.

In the end, though, the decision to work at her house for that song was so good because Whitney was able to be in her element, comfortable in her own home, and do what she loved with people she loved. I can't help but think her love for Jesus—and especially his love for her—inspired her during that recording too.

<div align="center">❖</div>

When Whitney sang "Jesus Loves Me" during her live performances, she wasn't just performing, she was preaching. In 1994, she sang it in Brazil and gave the gospel message to the audience—telling them, "I love the Lord Jesus. I'm not ashamed to tell the world about him." In that performance, she shifts back and forth between preaching and singing; it's a beautiful, passionate display of faith in song and message. ◼ GO TO TheWhitneyIKnewVideos .com TO VIEW THIS AND OTHER BONUS MATERIAL. The people who doubted her faith or thought it a charade simply didn't know Whitney.

When I play the song now and hear her sing the line, "See, sometimes I'm lonely, but I'm never alone," my heart hurts. There were times in her life when she certainly felt lonely and, I would venture to say, times when she felt alone. I think gospel music always brought her back. I think that singing and feeling that joy again was her way of finding her way back to Jesus.

This life trembles beneath the waves of hurt and loneliness, and no one is exempt. The people who we think are the most successful and have it all together are often the ones who are unraveling underneath. Whitney had music, her family, and her faith to guide her during the hardest of times. But so many people feel they have nowhere to turn.

If Whitney were here now, I think she'd say that's one of the reasons she sang: to bring hope to people. Her voice could bring light to the darkest of days. Thousands of people said so in their tweets and blogs and YouTube comments after her death. Yet sometimes those who have the ability to bear the most light are the ones who fall into the deepest dark. And who is there for them? Who picks them up out of the pit?

The Scriptures say that when we are at our lowest, Jesus reaches down and pulls his children out of the pit. Whitney always seemed to find her way back into the light; she always seemed to find the strength to bear the light so others might have hope. My prayer today is that we return the favor—that we bring the light back to our princess and remember her in the way Jesus remembers each of his children: redeemed, made new, reborn, restored. Because that's what she is now, now that she's Home.

<div align="center">⁙</div>

My friend Maya Angelou wrote a poem for President Clinton's inauguration entitled "On the Pulse of Morning."

Lift up your eyes upon
This day breaking for you.

Give birth again
To the dream.
Women, children, men,
Take it into the palms of your hands.
Mold it into the shape of your most
Private need. Sculpt it into
The image of your most public self.
Lift up your hearts
Each new hour holds new chances
For new beginnings.

The poem calls us to lift our eyes to change—to a new day in which to dream and to be the person we always knew we could be. Maya's words also challenge us not to give in to fear but to overcome fear with grace. You and I need grace daily. Just as we have a deep need for it, so also do our friends and family members and neighbors. I love the idea of stepping forth with a new dream and allowing that dream to shape our lives.

Whitney took hold of her dream. Her success inspires and infuriates us. We love that she had it, but we're not sure if the exchange was worth it in the end. Sometimes you give up so much to attain what you can only dream about.

Whitney needed grace during her lifetime, and she still needs grace from us in death. We need to be okay with the highs and the lows of this life. We need to not let fear take our grace away, for it is by grace that we achieve our dreams. Grace gives us the freedom to pursue our dreams and the confidence to fail. In the Bible, the apostle Paul attributed our very salvation to grace—and grace is a gift. An unearned yet costly gift.

Whitney preached grace, and she seized as much of it as she could from a God who grants it freely. She'd want us to do the same.

❖

A few weekends ago I was blessed to be invited to sing at St. James United Methodist Church in Alpharetta, Georgia, where Whitney would attend when she was at her Atlanta residence. It was through Whitney's funeral that I became connected with the church—a church endeavoring to do great things in the community and for the Lord.

Before I sang, the choir offered up a rousing number led by an exuberant young man. The people of this church were clearly gifted in their ability to sing and play instruments. Afterward, the lead pastor addressed these talents and praised God for the gift of worship. I was struck by the pastor's humility and sense of responsibility regarding worship.

It seemed natural to me that Whitney would attend such a church. I'm sure it felt like home to her: people standing all over the auditorium playing tambourines, raising their hands in prayerful worship. This church fit Whitney.

The pastor said something else that struck me. During the singing he approached the pulpit and brought the congregation back to the heart of the matter: "We need to be careful," he said, "especially in this day and age, not to confuse entertainment with worship."

The line today certainly gets blurred in churches all across America. But I reflected on the way Whitney fused entertainment and gospel—worship—so effortlessly. She was able to entertain with the best of them and then transition into a truly heartfelt gospel

number. Whitney understood what it meant to have fun, there's no doubt about that. But she inherently knew how to guide that passion for the entertaining moment into a moment of reflection and wonder.

Now I'm sure that plenty of the folks attending her concerts were not too interested in joining in a worship service, but Whitney didn't care. She sang the songs that made her feel good. She was blessed with worship, blessed to sing the songs that made *her* heart sing. That's what made her special.

I've often said that a good song speaks to the heart. One friend of mine reminded me of the words of poet Robert Frost: "No tears in the writer, no tears in the reader." Yes. Perfect. That's what Whitney knew. The songs that moved her would move her listeners, and the songs that moved her were the songs with deep meaning—gospel songs, songs of faith and hope that pointed her home.

<center>❖</center>

One line in "Jesus Loves Me" says:

Little ones to Him belong
They are weak, but He is strong

I don't know how many times I've sung these lyrics. The context is almost always little kids singing to parents, and parents "oohing" and "ahhing." But I sensed when the lyric says, "Little ones to Him belong," it's not only talking about children. I think it's talking about us adults.

When Whitney sang "Jesus Loves Me," I saw and heard a child.

I think the song was her invitation to each of us to become a child again. *We* are the little ones. *We* should allow ourselves to open up once more to what God wants for our lives.

I believe that during Whitney's time away from doing music, during her marital turmoil, she realized she had wandered from God. The lyric I added to the version of "Jesus Loves Me" that she sang for *The Bodyguard* single became her prayer years later, I think. I'm convinced with all my heart that this should be my prayer and yours as well:

> *Pressing on the upper way*
> *Always guide me, Lord, I pray*
> *Undeserving and stubborn will*
> *Never fail to love me still*

Amid all the headlines of Whitney's tragic death, we learned one telling detail: that not only was "Jesus Loves Me" the final song she performed publicly but one of the last songs—if not *the* very last song—she sang before she died. Despite her struggles and frailty, she still believed the God of her salvation loved her. I dare to believe a little further: That there in her hotel room, before she passed from this life to the next, she voiced it once more—"We are weak, but He is strong"—without any cameras around. A moment of private worship between one of God's children and her heavenly Father.

"Whitney was one of the great
vocal athletes of all time."

❖

The Voice

When I watched Aretha sing, the way she sang and . . . closed her eyes and that riveting thing just came out. . . . Oooh, it could stop you in your tracks.

Whitney

❧

What does it mean to be gifted? What do you do with your gift?

I answer the question about giftedness like this. In Whitney's case, there were (and are) plenty of singers in the world. And by *gifted*, I mean, they possess obvious vocal talent and may even be able to make a career out of singing. Was Whitney gifted? Obviously. Her enormous talent oozed out of her.

But with Whitney there was something else. So many people saw and heard it, but few can find the words to express it. When Whitney's mentor, Clive Davis, first heard her sing at the Sweetwater Club in Manhattan he said, "To hear this young girl breathe fire into that song . . . it really sent tingles up my spine."

This is why I laugh at the notion that she sold out the black community and didn't sing with soul. The girl was straight-up anointed, and younger black artists, both male and female, from the range of genres today—rappers, hip-hop, R&B, pop, and gospel artists—have all credited her as a guiding star on their musical journey.

Now, those of you reading this who didn't grow up in the church are probably wondering what in the world I'm talking about when I say she was "anointed." Don't worry, I'm not going to crack you over the head with a Bible. But a little context might help.

One easy-to-understand example of an anointing in the Bible is when a shepherd boy named David was anointed to become king. The prophet Samuel anointed David by pouring oil on his head to signify that he was God's choice to be Israel's next king.

Anointing is a special setting apart by God, intended for his glory. In my opinion, the great black minister E. V. Hill was anointed. When he preached, the walls shook and people's hearts shook and those heart walls came tumbling down.

If you've ever heard evangelist Billy Graham preach, I would say you were hearing an anointed man—a man whose words have been set apart for a special purpose. For decades, he preached simple sermons that persuaded hundreds of thousands of people to the Christian faith all over the world.

Are you feeling my words? Am I doing a bit of preaching? Sure.

Larry Busacca/Gettyimages

Before a watching world, BeBe Winans honors
the Whitney he knew at her homegoing service in
Newark, New Jersey, on February 18, 2012.

Images courtesy of the author's collection of photos.

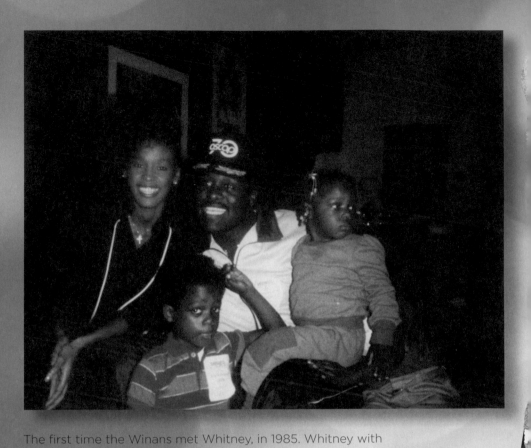

The first time the Winans met Whitney, in 1985. Whitney with BeBe's brother Carvin and his children, Carvin III and Ebony Jay. Whitney was opening for Jeffrey Osborne.

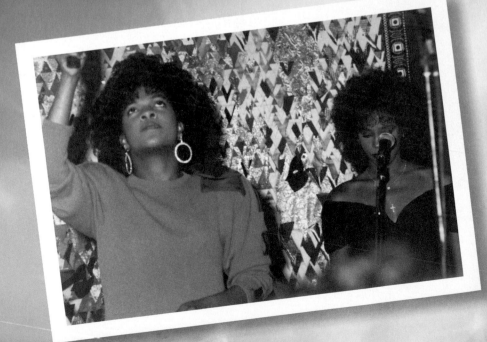

CeCe, Whitney, and BeBe in the studio at the recording of "Hold Up the Light." BeBe's shirt says Friends Forever, which is what they became.

Left: CeCe and Whitney at a charitable event to honor Whitney's mother, Cissy Houston. The entertainers were BeBe and CeCe, Whitney, and Luther Vandross.

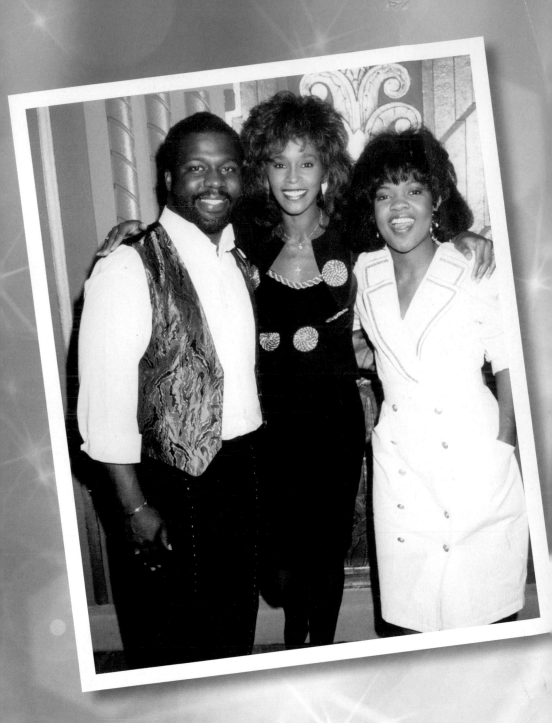

BeBe, Whitney, and CeCe at their first major concert after-show "Meet & Greet"—at the Wiltern Theater in Los Angeles, CA.

Whitney, BeBe, and CeCe at their first major concert at the Wiltern Theater. These are the outfits that Whitney had made specifically for the show.

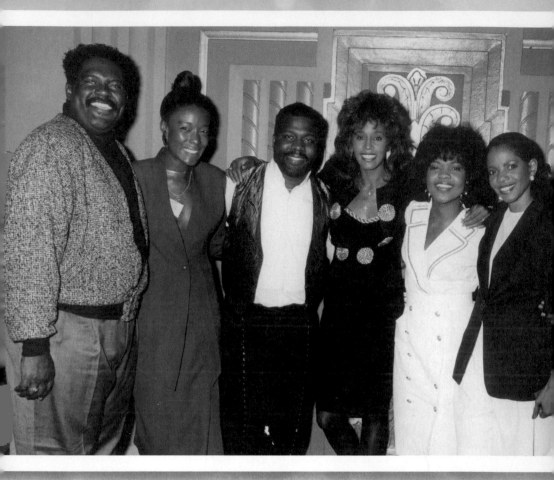

Photo: Arnold Turner

Ronald Winans (far left), BeBe (center), Whitney, CeCe, and actress/singer Melba Moore (left to right) at the Wiltern Theater after-party.

Whitney and CeCe in concert at the Wiltern Theater.

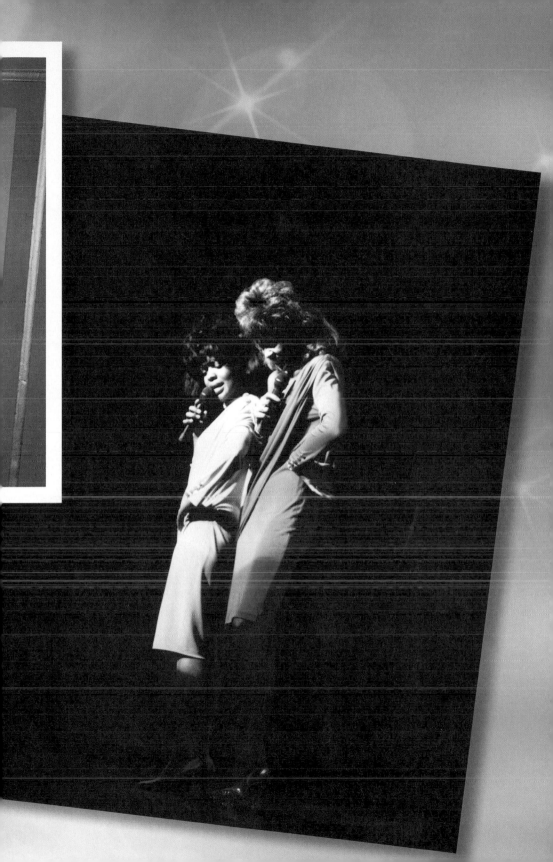

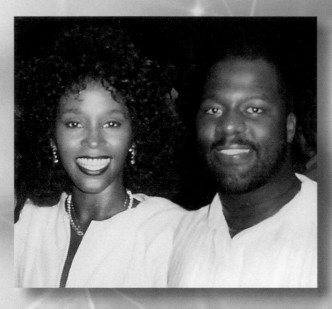

BeBe and Whitney at her 26th birthday party, where she received the live monkey as a gift from Michael Jackson.

Left: BeBe and Cissy Houston at Whitney's 26th birthday party.

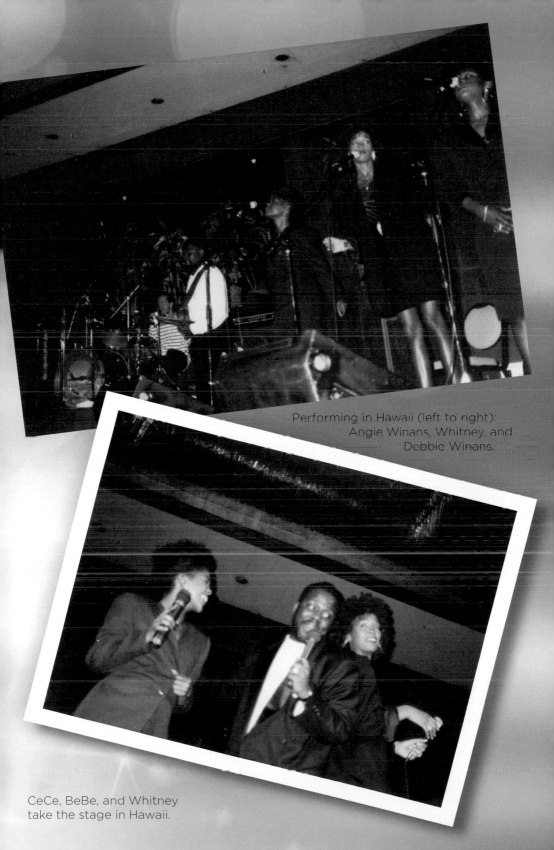

Performing in Hawaii (left to right):
Angie Winans, Whitney, and
Debbie Winans.

CeCe, BeBe, and Whitney
take the stage in Hawaii.

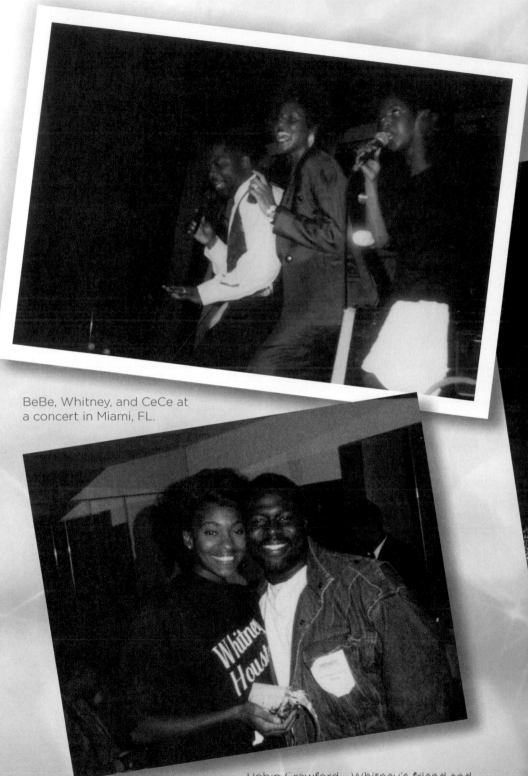

BeBe, Whitney, and CeCe at a concert in Miami, FL.

Robin Crawford—Whitney's friend and assistant—and BeBe, just after they first met.

CeCe, Whitney, and BeBe after leaving the SoulTrain Awards in 1989. BeBe and CeCe had a concert in Redondo Beach that same evening, and Whitney showed up at 10:25 p.m. to see the show.

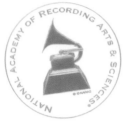

NATIONAL ACADEMY OF RECORDING ARTS & SCIENCES®

presents this certificate to
WHITNEY HOUSTON
DAVID FOSTER, NARADA MICHAEL WALDEN,
L.A. REID, BABYFACE, WHITNEY HOUSTON,
DAVID COLE, ROBERT CLIVILLES & BEBE WINANS,
Album Producers

in recognition of your

NOMINATION

for the
ALBUM OF THE YEAR

"THE BODYGUARD"
Original Soundtrack Album

for the awards period
1993

HANK NEUBERGER
Chairman of the Board

MICHAEL GREENE
National President/CEO

Left to Right:
Narada Michael
Walden, David
Foster, Robert
Clivilles, BeBe,
Whitney, Babyface,
David Cole, and
L.A. Reid accept
the Grammy for
The Bodyguard
soundtrack.

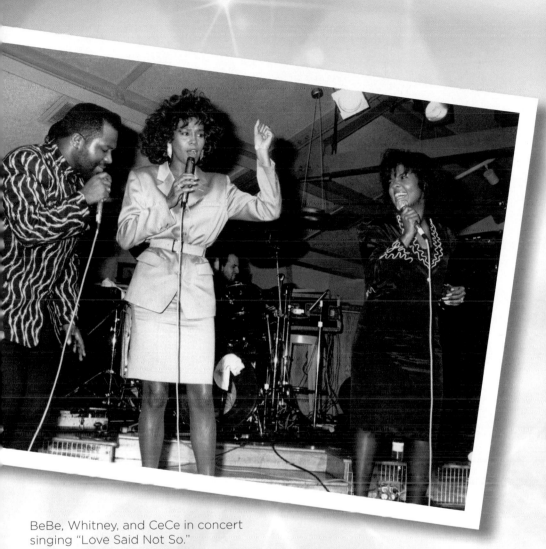

BeBe, Whitney, and CeCe in concert singing "Love Said Not So."

Family birthday celebration for Mr. Winans' 65th birthday party. Whitney was a part of this family and attended brother Ronald's funeral. Ronald is to the right of Delores Winans, who is front center.

Celebration of Delores Winans' birthday.

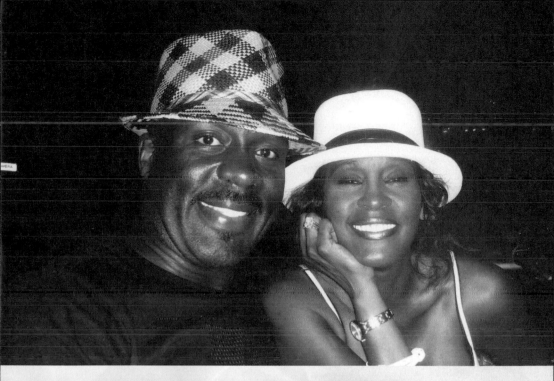

BeBe and Whitney at Atlantis Resort for Michael Jordan's Golf Tournament, 2008.

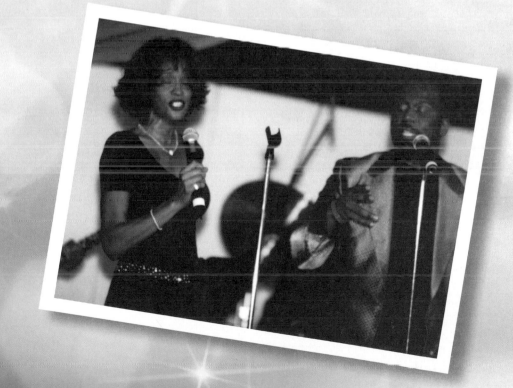

Whitney and BeBe performing at a concert for the opening of the
One and Only Club at the Atlantis Resort, 2004.

REUTERS/Mario Anzuoni

She was one-of-a-kind,
never to be forgotten.

Whitney could preach too. But her sermons weren't laid out in an outline. Whitney's sermons came from that "pool of soul" deep within her. Whitney's pulpit was not made of wood or metal. Her pulpit was a microphone stand and a piano or band. And her message was glory itself.

"The Creator has created. There will never be another Whitney Houston," said Maya Angelou after Whitney died. "She made the listener believe that he or she was doing the singing. . . . She sang not just to you, but through you. That's a gift."

In church, when you hear a good preacher, it's as if he is speaking the words directly to your heart or actually reading your mind and speaking the words you've always wanted to say to God but never could. That's what Whitney did when she sang.

<div align="center">⋯⊱⋮⊰⋯</div>

You use your gift—you give it away, just as we're supposed to do. Whitney knew from a young age that she loved to sing. When I heard her on the radio in that cab, I knew that I was listening to a person who understood they possessed something special.

When Whitney "reemerged" into the spotlight with *Sparkle*, her final film (being released in August 2012), so many were delighted that she was back. She looked healthy. She seemed wiser. She was ready to give it all another go. People were excited because she was using her gift again.

When she began filming the remake of *Sparkle* in Detroit, the first thing on her mind was attending church with Pastor Marvin Winans—my brother—which she did. Whitney showed up at church that first Sunday she was in town, and just before Marvin went into

his message, he saw her sitting in the congregation, waving at him. What could he do?

"I just want to come give you a hug," she shouted from the audience.

Marvin, knowing this was Whitney being Whitney, told her to come on up and get it over with. So she ran up and hugged him. Marvin didn't know that would be the last time he saw Whitney alive.

But there she was, back among us—her fans. When those who possess such special gifting leave us for a time, we miss them. We always want that initial burst of glory we saw when they first arrived on the scene. When Whitney returned to the public light, the "every woman" had returned, hopefully still bearing her gift.

She brought her gift with her for sure. But she also brought with her a more mature understanding of her gift—something that is easier said than done. She showed up on time or early for the six weeks of filming for *Sparkle*, executive producer Avram Kaplan reported. No personal stylist doing her hair and makeup, just down-to-earth, who-she-was Whitney. Yet when she took the stage to sing "His Eye Is on the Sparrow" for the film, stand-in Stefanie Mitchell told *People* that everyone got "really emotional. The extras couldn't stay in character. Even the director and producers couldn't keep it together." The reason? Whitney was singing what was in her soul that day.

I sing because I'm happy
I sing because I'm free
His eye is on the sparrow
And I know He watches over me

(Civilla D. Martin, 1905, public domain)

Whitney's extraordinary gift brought her into the lives of so many people—tens of millions of fans, as well as dignitaries of every ilk and industry. Once, the Sultan of Brunei paid Whitney more than six figures to perform a concert for his daughter. Another time, she headlined at Nelson Mandela's birthday party—a "little" gathering in London's Wembley Stadium. And, in 1994, after a fundraising concert for South African children's charities, a grateful Mandela claimed he was there "merely to polish her shoes."

It takes a very grounded person to protect their gift in those kinds of circumstances. Really, you have to even protect it from yourself. When people start throwing huge money at you to perform private concerts, or international leaders claim they are unworthy of you, you have a whole new set of blessings *and* problems to deal with.

Temptations arise. Corrupting temptations that may not feel like they're all that terrible. But in our humanness and hunger, we may—like Cain in the biblical account of Genesis—wish to sell our birthright for our own selfish gain.

This is the stewardship question that many brought up with Whitney: did she abuse or misuse or abandon her God-given gift? Even though I don't believe she sold out her voice for selfish gain, she always wrestled—especially in the early days of her career—with understanding the enormity of what she'd been given.

For Whitney, her task wasn't just performing at concerts. It was staying healthy both physically and spiritually. As many were quick to point out, staying focused in a "Whitney world" could be very tough. By staying focused, however, you are better equipped to see the adversary—and the adversary may be yourself. It may also present opportunities you should not take.

Whitney would learn these lessons firsthand.

⋅⋛⋅

The biblical book of Proverbs says that one's gift is a tremendous responsibility and blessing: "A man's gift makes room for him, and brings him before great men" (18:16). Whitney's gift paved the way for her success and for worldwide recognition. She was hailed, not just by the entertainment elite, but by men and women with power: presidents, business leaders, culture-shapers.

The reality is that every decision we make in life builds on a previous one. Though our gifts blaze a path before us—opening doors and clearing new terrain—we must always remain cautious of where those pathways and doors lead. It's the little foxes that destroy the vineyard. Demise doesn't just happen; it occurs over time.

So it goes with addiction. It starts with something very small—for Whitney, perhaps as small as a decision to sing for a public audience rather than to sing just for church, or to pursue her passion for music rather than the passion she had for basketball.

That decision about what career path to take—often rather innocuous in the past—now can assume larger meaning, because we live in a different era. These days, when you ask a young person what they want to be, it seems they're almost as likely to say that they want to be a star as to say they want to be a doctor or a teacher. But most young people don't know the cost of the celebrity life. Why? Because it's presented like candy; it starts with a taste. And if you believe the candy is sweet—the golden ticket for entrance into Willy Wonka's Chocolate Factory—without understanding the price to be paid, your defenses will break down. This is why it is so important to know who you are *before* someone entices you with outside pressures.

Whitney knew who she was early on in her career. But her rise to stardom was so fast that it thrust her into an EF-5 whirlwind that took her years to make sense of. She learned from her mom and from Dionne, among others, about her gift—how to use it and how to make it better—but truly catching up with the ins and outs of what was expected of her, and learning when and how to say no to the demands that were placed on her, was a lifelong process.

When her career took off, it was difficult for her to keep up with it all. So many people entered the rhythms of her life—from security details to band members to financial managers to publicists and attorneys. She barely knew who some of those people were. And when you don't have relationships with the people who are running your business, it's hard to know who is working on your behalf and who might be stealing from you.

Years down the road, Whitney would learn who was trustworthy and who wasn't. When people proved disloyal—especially for someone like her, who was so fiercely loyal—that knowledge hurt. It's hard to recover from that kind of hurt. Yet it's those kinds of stings—those business stings—that take the joy out of using your gift.

This part was particularly hard for Whitney. She loved people and *wanted* to trust them.

To be fair, I don't think people understand the amount of pressure a gift like Whitney's brings with it. Picture it as being lost at sea. It's more than an ocean; it's vast and overwhelming. Even lifelong friends aren't exempt from taking advantage of and benefiting from the gift. NFL quarterback Michael Vick has talked about how he had to cut things off with some of his lifelong friends and even family members after he was jailed for dog fighting. His experience evidenced the biblical axiom that bad company

not only corrupts good character, but it can also bankrupt you financially and spiritually.

Think about it. You go to work. You're a friendly person, you're kind, you're generous, and you love to smile—like Whitney. But someone can rob you because of your kindness. Some people can and will take advantage of you if you don't protect yourself from the little foxes.

Understanding and protecting the gift: it's vital! A precious personal gifting should be treated like a jewel. When a diamond is on display at a museum, authorities go to great lengths to guard it. Many times, thieves come from within—an inside job. You can almost count on insiders selling you out to people on the outside. This was never more evident than in the events that followed Whitney's death. Even then people tried to gain financially at her expense. A picture of her in her casket? Really? That's not a loving act, that's thievery.

Some would argue that Vanessa Williams didn't understand the importance of protecting her gift when she was younger. When her beauty earned her the Miss America title, we learned that she had already allowed others to exploit and soil her gift for their own gain. She wasn't proud of her decision, and that decision haunted her, her family, and those who admire her, for years.

That's why I love God's grace and second chances. To see Vanessa Williams now, as celebrated entertainer and actress, is nothing short of heartwarming. Now she understands exactly how to protect her gift.

Whitney's life stands as a reminder that the beautifully gifted among us can and often will be soiled by our culture. We blame Whitney for not protecting her gift. But what about us? Do we see

the beautiful, the talented, the special, and run to exploit them? Or do we see their lives among us as a little bit of heaven, a little piece of God's glory embodied in human form?

The same people who were so excited that Whitney had returned to the limelight were probably the same people who said that she abused her gift or sold out the black community for fame and money. From my perspective, the only sell-outs are the people who turned their backs on her simply because of the way she died. Whitney's gift was the reason for her fame. And while she struggled with temptation, I believe the only thing she sold out were venues.

I won't argue with those who perceive her substance abuse as a demeaning of her gift. What people fail to understand is that Whitney lost her voice a couple of times, not because of substance abuse, but because she was exhausted and struggled to quit smoking cigarettes. That may come as a shock to some, and I'm not saying that Whitney was a chain smoker, but she did smoke cigarettes. Hard-core drugs, however, make a better headline.

Substance abuse—though a very real issue with Whitney—was not the sole cause of her waning voice, and in my opinion, it wasn't even the primary cause. From the time Whitney started smoking socially (when we were younger), up until she died, I always challenged her to stop. "It will ruin your voice," I'd tell her. Whitney's own godmother, Aretha Franklin, confessed that her high notes were leaving her because of cigarettes. And yet I could never convince Whitney to give up smoking, even though losing her voice made her feel incomplete.

None of us are our abilities alone. I fully believe that every aspect of our being as crafted by God constitutes who we are as people. Yet

for Whitney, her voice was her identity. It was only a small percentage of the total woman she was, but her voice was tied so intricately to her soul—and it so tapped into her joy and faith and love—that when she sang, she felt 100 percent complete. And knowing how much she loved to sing, I can't shake the idea that she spoke to us when she sang.

<div align="center">❖</div>

As I listen to her songs on iTunes and click through personal and YouTube videos, I'm *re*-astonished, if that's possible. Maya Angelou was right: I walk right into Whitney when's she singing.

It happened for a watching world when she sang the National Anthem on that Super Bowl Sunday so many years ago. But it also happens for me when I watch her sing with CeCe. I see her hold my sister's hand and look at her like any loving sister would look at her younger sibling—with such deep care and adoration. Whitney's countenance allows me, the viewer, to enter more deeply into the song. Why? Because I'm invited into its story by the singer.

I can sing a song on stage and the performance can be just humdrum. Or I can talk to you through my song, convincing you of something you never knew before or inspiring you toward something you never thought possible. That's the magic of music. That's what Whitney did so well. She beckoned to us: "Come in here and walk around with me."

Whether a wispy love ballad or a jubilant gospel song, Whitney *became* each song that emanated from her vocal cords. You and I have our particular "languages." We bare our souls through our work or our art, our leadership or our philanthropy. I think most of

us, however, can hear that special language of music. It's a universal language clothed in different styles. Songs help us communicate our deepest hurts and apprehensions and anxieties and desires.

Whitney may have been called "The Voice," but she believed everyone had a voice, and that each voice could and should be heard. Sometimes the best way for our voice to be fully heard is to tap into someone who seems to beautifully and persuasively be saying the same thing we're feeling. I think that's why so many of us look to people like Whitney. We understand their language because it's ours—they're saying what we are, and they're expressing it in the way we wish we could. When we link to a voice like that—in whatever our area of passion or expression—our confidence grows and our own voice is magnified.

I can hear Whitney singing to me on the phone even now. We loved to sing. And that love united us. I wonder what would happen if those of us who are still here on Planet Earth would let our voices unite for the good of one of another. I think we'd all live in perpetual song. Whitney would've loved that.

"The Whitney I knew was still wondering if I'm good enough. Am I pretty enough? Will they like me? It was what made her great, and what caused her to stumble at the end."

❖

KEVIN COSTNER
Speaking at Whitney's funeral

The Bodyguard Couldn't Protect Her

[Kevin Costner] called one day and said, "Listen, are you going to
do this movie with me or not?" I told him about my fears.
I said, "I don't want to go out there and fall." His response was:
"I promise you I will not let you fall. I will help you." And he did.

Whitney, about starring in *The Bodyguard*

❧

I collect pieces of life. They're spread all over my house inside
wooden and metal frames. Some are large, almost larger than
life. Others are small. They are pictures held forever in the time-
lessness of a frame. All tell the same story, though: the story of a life.

One room of my house holds a desk and a computer and a
bookshelf—nothing too out of the ordinary. But the room jumps

into the extraordinary when I look at the walls. On those four walls I keep the memory of Whitney. I used to walk into that room and feel invigorated and challenged, but now, not so much. Those walls hold the platinum single "I Will Always Love You," which included "Jesus Loves Me"—the song I produced and arranged for Whitney.

As I survey the walls, the photos sing to me. Those particular frames hold so much more than mere photographs. They hold the voice of a friend. They hold her laughter—the laughter of her excitement as she told me "Jesus Loves Me" would be included on the single. They hold the lyrical memory of our relationship that crossed from stage to family to kitchen to closets.

"BeBe, guess what?"

"What you got?"

"'Jesus Loves Me' is going on the single, and on the movie soundtrack!"

"You're kidding! Don't go messin' with me."

"I'm not messing with you! This is real. It's happening!"

She was almost more excited than I was. That's one of those phone calls you receive that you never forget.

We talked and talked about the song and the album—all of it. Neither of us had any clue how successful the single, the album, and the movie would become. Our initial reaction and excitement captured the whole moment—the unknown and the possibilities of what *could* happen, the joy of being able to work together.

Those are the moments that you live for and cherish. That was a good phone call.

But I also remember the phone call we had before *The Bodyguard* even became a reality. At this point in Whitney's career, she was really

soaring, all over the charts. And she was getting offers from all kinds of movie people. There were a slew of leading men who wanted to do a film with her. I think Robert De Niro was one of them, well before *The Bodyguard* project was on the map. He wanted to do a film with her for her beauty alone. And who would blame him?

Yet even though Whitney was sought after by movie greats, she turned down those opportunities, willing to wait for the right timing. She wanted the project to make sense for her, and she wanted to feel comfortable with whomever she was going to be acting.

Kevin Costner was the right choice. He asked Whitney to do *The Bodyguard,* and after much hesitation, she agreed.

At the funeral, Kevin told the story of how it all materialized.

Some people thought he should go for a more seasoned actress. Others thought perhaps they should try and find a white actress instead. Kevin, however, *knew* that Whitney was perfect for the role. Even when he discovered Whitney's tour schedule would keep her from doing the film, he remained true to his instincts and postponed the filming for a year, until her tour was done.

The kind of solidarity he showed in that decision speaks volumes to me. The kind of belief he had in Whitney's ability to pull off the role is exactly what Whitney needed.

But what resonated with me even more than that story were his insights into Whitney as someone who still needed to hear from her mother that she was good enough. When I heard Kevin talk about the questions that Whitney would ask privately of herself her whole life—those *Am I good enough? Will they like me?* questions—I nodded in agreement.

In our early conversations about doing the movie, Whitney sounded just like the teenage girl Kevin described in his eulogy—an

excited little girl who still needed to have a friend tell her that she could do it.

"BeBe, I'm a bit nervous about this. What will they think of me? What if I'm awful? What if the project doesn't do well?"

She really asked me these questions! Hard to believe, knowing now how that movie and soundtrack not only succeeded with the masses but broke major industry records. And yet the critics weighed in on Whitney's performance, many of them tinged with negativity if not outright unkind. The very thing she feared, happened, shadowing this great success. Which may explain why, around this time, she admitted to *Entertainment Weekly*: "I almost wish I could be more exciting, that I could match what is happening out there to me."

Can you imagine? And yet, at the heart of every person is the need, even the drive, to be liked and accepted by others. You and I want to perform well in our jobs. We want to be noticed by the boss. We want to receive an accolade or two, and a bump in pay sure would be nice. In this sense, Whitney was no different from the rest of us. She was once a child who needed to hear that she was special and had something to offer.

That's a hard thing to imagine. Whitney Houston could do anything, it seemed. Whitney Houston feared nothing. She had the world. All she had to do was ask.

Not quite. At the end of the day, Whitney had to go home to a spouse and a child and do the everyday things that make a family work. She had to deal with life at home and life on the road and life in the limelight. And in all of these, she wanted to find success and significance. She thought about it and worried about it, just like you or I would.

This special room of mine holds deep memories. The kind you

can get lost in if you sit long enough. When I look at the commemorative frame that holds the platinum record for *The Bodyguard* soundtrack, my eyes move right to the picture of Whitney at the center—her back facing the lens. In the photo she's wearing a long form-fitting dress with a train on it, much like the one at the end of the photo section in this book. Her head tilts down and to the side, like she's walking off the stage and reveling in the moment.

When I see this tribute piece on my wall, I can't help thinking that this particular picture and the award itself were the world's way of saying to her, "You did good, girl." But where is the award for being a real person? What about the recognition for being a true human being? What about the need Whitney had to not only be respected professionally but personally? I wish we did a better job of letting people know we appreciate them in spite of their success and fame.

<div align="center">⋅⋅⋅⋅</div>

Every person lives a double life to some degree. We're actually, though perhaps unintentionally, taught that lesson as kids when our parents tell us to "be on our best behavior." Once we get home, whether it's from church or school or the neighbors' house, the makeup comes off. The harsh words fly. The attitudes flare up. We're able to remove our public veneers and show our true selves. But for an international celebrity like Whitney, she almost never got to be herself until she was alone or with her inner circle, because when you're in front of the cameras and the crowds, you have to be a certain way.

When the media finally goes away, what was a person like Whitney left with? Well, the media never went away. So right or wrong, we

see Whitney pulling off "The Star-Spangled Banner" to the raves of a nation, and then we're reading about drugs and her home life later.

I still get questions about Whitney's substance abuse problems. It's like people want more information than they already have from the vast archives of Google. What else do people really want to know? Isn't it enough to know that she struggled?

Kevin Costner's response to Anderson Cooper was right. "Was she doing drugs during *The Bodyguard*?" His answer: "Not that I know of."

I would answer that question the same way. You ask, "BeBe, did Whitney do drugs around you?

"No, she didn't."

Did we have an open relationship where we talked about her problems? Yes. But I didn't hound her about things. She knew I loved her and wanted the best for her, as any brother would. In this regard, our relationship was just like any relationship you have with your friends. You talk about everything—behind closed doors. But you don't sift through the deeply personal stuff when you're sitting at dinner with other friends and extended family. You wait till the time is right: when there's breathing room for your trust to work itself out and for the really personal stuff—the things you hold close to your heart—to be brought out into the open.

So, Whitney was just like you—she waited for those times to divulge the personal stuff. And, just like you when you're at church or at work, she put on her "makeup," so to speak. She became "Whitney Houston"—the Whitney that everyone loved, but not the whole Whitney.

Maybe Whitney shared with her close friends about the addiction, and some of them, like Kevin Costner—who wrote a letter to

her in an attempt to reach out—tried to help. Members of her family did as well. But at some point, you have to face the truth that Whitney is a big girl, and if she doesn't want the help, she's not going to take it. Still, her addiction didn't cause any of us who were close to her to love her any less.

I gave her the space she needed. She knew that at any time she could call or drop in and talk.

·:·:·

The Bodyguard years were tough on Whitney. She wasn't just releasing *The Bodyguard* soundtrack and watching it explode. There were the myriad demands—publicity, promotional appearances, interviews—that come after an album is released, but multiplied by a thousand because the movie and the music were such blockbuster hits. In fact, her success at the time was described as "relentless" by *Entertainment Weekly*. So Whitney was being pulled in one direction by all those business demands, and then she had the demands of the heart—the calls from home, the weeks away from family, the expectations and longings of a new mother and a newly wedded wife—pulling her in another direction. Whitney really wanted to make her marriage work, but it was tough.

Throughout that three-year journey, I was there, supporting her and helping her where I could. Sometimes it was from a distance; other times I was producing set lists for her.

I remember one afternoon I was driving with my friend, EMI music publisher Evan Lambert, and we were talking about what Whitney should do to open up her concerts for *The Bodyguard* Tour. I called her and said, "I've got something to send you."

"I like this idea. Can I use this?" she asked.

The tour opened in Miami. I wrote out her first song and what would happen production-wise—what she'd do, where she'd come out on stage, everything. But it all was going wrong leading up to the first show. She was an hour late, the air conditioner wasn't working, and the lights went off. The crowd became restless. People started booing.

But then, the interlude started. And then the music for "The Greatest Love of All" began, and Whitney broke into it, just as planned.

The crowd's mood changed in an instant. They went crazy.

So some things worked out after all. And Whitney included us on her journey everywhere she could. A little-known fact: Whitney started a music label through Capitol Records around this time, and my sisters Debbie and Angie were on it. Whitney sang backup on their album, and Whitney had them open for her on *The Bodyguard* Tour.

And then there was one night in particular that I remember, when I attended their concert at Radio City Music Hall. I had flown into New York that day, but my baggage was lost, so I was very casually dressed and was just standing in the back of the venue, taking in the production. All of a sudden, Whitney started talking about how I helped out on "Jesus Loves Me."

"Is my brother BeBe in the house?"

I couldn't believe her. I was in overalls!

"Turn those houselights on. BeBe, raise your hand—there you are, my brother!"

I was so embarrassed. But that's what family does. We keep it real for each other.

I helped her keep it real by just listening to her during this rough time. That was huge to her. It didn't matter how she acted or what she said, I would tell her how I felt and what I thought.

We all need that from those we love. We need to know that they have our backs, but that they will also let us know when our egos become too big for our own good.

Still, despite all our conversations, I'm uncertain how she was able to sustain a new marriage and a baby and her meteoric rise, which reached Michael Jackson status. I'm sure that during that time is when her coping mechanism turned dark. Rather than being with family and friends—which is very difficult to arrange when you're touring the world—she chose other means.

Sometimes the only thing you can do to help those you love is to let them know that you're always there, no matter what. That's what I did. I think the fact that CeCe and I were around, helping out where we could, allowing her to be part of our lives and careers, was a gesture that meant more than words to Whitney.

"I had an opportunity to introduce Whitney Houston.
[Her performance] was the most electric moment
that I've ever seen in sports."

FRANK GIFFORD
On introducing Whitney at Super Bowl XXV,
before she sang the National Anthem

Our "Star-Spangled" Moment

Now, look, don't embarrass us.

BeBe to Whitney, playfully, before her Super Bowl solo

❧

When Whitney sang the National Anthem at Super Bowl XXV in Tampa Stadium on January 27, 1991, time nearly stood still, and America's song would never be the same. She set a standard so high, so flawless, that most consider it untouchable. More than twenty years later, it remains a legend—a YouTube hit, a record-breaking single, the defining musical moment of a generation newly at war in the Persian Gulf.

Desert Storm was only ten days old when Whitney stepped up to the mic and, backed by the Florida Orchestra, made history. A

reported worldwide television audience of 750 million watched, about one-fifth of them Americans. And for the first time ever, our troops in the Middle East were able to be part of the moment too, via live telecast. It created a shared experience for humanity, bringing Americans together from nearly every corner of the world.

"She was pure of timbre and bursting with emotion," wrote Lisa Olson, *AOL Fanhouse* columnist, in recalling that breathtaking performance. It was "the night when Houston's majestic voice bounced off stars and circled the planet." And when Olson learned of Whitney's death, it comforted her—like it does so many people now—to remember how Whitney, for that two minutes on a January evening, "humbled us, left us in awe, and made us feel so very connected and alive."

Whitney called me before she sang, and I told her what I always told her: "Now, look, don't embarrass us." And what I meant was that since we all (Whitney, CeCe, and myself) had gospel roots, she had to *represent*. And she knew it.

We were always playing around about not embarrassing each other—but we still respected the notion. It's what made us so close. I said it to her then, just like I heard her saying it to me while I was seated in the church pew at her funeral.

After Whitney and I exchanged a few playful barbs with each other on that Super Bowl Sunday, we hung up. Then she walked onto a global stage while I, along with the global community, watched that skinny young woman from East Orange—in her red, white, and blue warm-up suit—sing her guts out.

But did the world watch and listen to Whitney sing as much as we watched and listened to Whitney paint a picture of hope and confidence that we so desperately needed at that pivotal time in

our nation's history? "If you were there," she would later say, "you could feel the intensity. . . . A lot of our daughters and sons were overseas fighting. . . . We needed hope . . . to bring our babies home, and that's what it was about for me; that's what I felt when I sang that song." ■ **GO TO TheWhitneyIKnewVideos.com TO VIEW THIS AND OTHER BONUS MATERIAL.**

While the troops were serving in Desert Storm, Whitney brought her own storm to the world's stage. With each word and note, she seemed to be saying, "We will make it through this time together—come what may." The football fans forgot all about football for that brief moment in time. They were caught in her whimsy, a magic that she wove into the sky just in time for the F-16 fighter jets to rip through, stamping her performance with an emphatic, "Yes, we are brave! Yes, we are free!"

And there she stood, arms raised in a confident "V", her fists tight and her mouth open, holding that perfect note, then melting into her angelic smile. What could eclipse that moment? Everyone watching *knew* they had witnessed not only a never-to-be-forgotten performance but also the transcendence of an artist into the stratosphere of fame. If you didn't love Whitney up to that point in her career, you loved her now. You loved her forever.

I remember when she finished, she called me and asked, in her typical playful way, "Well, how was that? Did I embarrass you?"

"Um, you *nailed* it. In fact, you probably sang it so good you ruined it for the rest of us. No one can sing that song now without thinking of that performance you just pulled off."

⋯⋅⋄⋅⋯

Before Whitney's death, she and I discussed the new album project I was working on. It was a collection of patriotic songs, including "The Star-Spangled Banner," and she would kid me about it, reminding me that she had nailed that song and sold a ton of copies to boot (all of her proceeds on the platinum-selling single went to charity). Jokingly, she said, "You sure you want to record it?"

"I'm not afraid of you, girl! My God is your God," I proclaimed. And we laughed.

But she always encouraged me—always stood by my abilities as a songwriter and a singer (though few people know that she arranged the vocals for that "Star-Spangled" moment). She thought I had the right to do the patriotic album and couldn't wait to hear it. But I wasn't fooled: "The Star-Spangled Banner" will always be Whitney's song. Those remarkable two minutes at the Super Bowl are forever etched into her legacy.

Yet even after she did something so amazing for so many people to experience, she remained the playful girl I met that night in Detroit. When I watch the video of her singing that song on such a grand stage, I see what everyone else around the world saw: *true* Whitney. When she sang, her eyes glimmered and her mouth smiled and the words smiled and rose too, and then the tones rising out of her took on a new aura. Each one of us could see the rockets' red glare; we could hear the bombs bursting in air. They were bursting from the veins in her neck as she effortlessly pushed those notes into the solar system.

Just like we did when she performed it live, now we watch on our computers and still hold our breath, marveling at her gift. We choke up at the end because we know that Whitney isn't merely singing a song, she's communicating her heart. And that's what separates

singers who sing, from the singers who *sang'e*. It's that magic fusion that we just can't explain other than, "God, this voice had to come from you. It had to come from heaven."

<center>⬥</center>

Something else came from her performance: unity. Whitney, more than any person I've ever known, had the uncanny ability to bring people together. No matter your race, religion, or creed, she blurred whatever lines the culture tried to draw. When she sang at the Super Bowl, Whitney wasn't only a beautiful black woman. She *was every woman*—and every man for that matter. I wouldn't be surprised if people of every ethnicity watched that performance and felt a family connection to Whitney.

She smashed stereotypes and bridged a racial gap in our country like few who've gone before her. And she and Kevin Costner did the same in *The Bodyguard*, with the interracial romance portrayed between their characters. Color mattered little to the film's audience, and not at all in the film itself—33 million albums and $400 million in ticket sales made that crystal-clear. Whitney tended to "extinguish . . . boundaries," as *Entertainment Weekly's* Sheldon Platt put it, again and again. And her performance of "The Star-Spangled Banner" was proof once more that our differences should not overshadow our similarities and our common languages of love and music.

That was Whitney's "Star-Spangled" moment. She brought together each person within earshot and made him or her part of her family. That night, a nation stood as one.

"It had to be a lonely life sometimes,
on a pinnacle up there alone.
It had to be hard to maintain.
But even Whitney not at her best
[was] better than everyone else."

❖

SONGWRITER DIANE WARREN

Whitney Unfair

When I became "Whitney Houston" . . . my life became the world's.
My privacy. My business. Who I was with . . . I just wanted to be normal.

Whitney, in her interview with Oprah

❧

Whitney didn't have a trophy case; she had a trophy room. Where do you think all those Grammys and platinum records went? They made their way to her trophy room and they sat there, under the lights, never making a sound.

Whitney is no longer with us, but her prizes in this life remain behind. None of them went with her. Now, do they mean nothing during this lifetime? I think they do have some significance, but not more than a small percentage of life's whole. They hold only the value of

the moment, and when that moment passes, they sit beneath those glaring trophy case lights, idle. You pass them by every day, glancing momentarily toward their gleam, but what more is there? After the lights go down and you've taken off your work clothes and slipped into your comfy shoes, you go back to your house and sit in your favorite chair and fall asleep, just like the rest of the world.

But a tension does exist, if we're honest. The awards and accolades accumulate and the feeling of success wanes, but out there in the world, your craft, your talent, your voice remains. It remains on vinyl records and cassette tapes, CDs, and MP3s. At any given moment, anyone can play your song. They can hear your voice singing passionately over and over again. Some simply click on to the next song or album, while others may sit and cry at the memory of where they were when they first heard that music.

Whitney knew this tension better than anyone. Later in her career, she knew that the public viewed her with some disdain, and that she'd made some bad decisions. Yet she also knew that people still listened and that her voice still mattered. The question so many wanted to know was, "Why? Why did you lose yourself? Why did you disrespect your gift? Why?"

You can't take back your songs. You can't take back the performances. And you can't take back who you are to so many. You can only cope and try to stay aligned with that version of yourself you know—the you that you truly are.

"Coping" was something Whitney did on her own. I knew she was coping when I didn't hear from her. The phone would stop ringing. The visits grew sparse. There was a sense of not being able to look one another in the eye—like when you broke your mother's vase as a child and you couldn't face her square and tell her.

When Maya Angelou was interviewed just before President Clinton's inauguration, Bryant Gumble asked if she would be able to control her emotions while reading the poem she'd written for the event. Of course she was concerned about her emotions. Why? Because of what she wanted to accomplish with the words—the high hopes that lay within the lines.

"I want us to look at each other," she said. "So often we find some place right up above the eyebrow line and we don't look into each other's eyes, as if we are afraid of that. . . . We will only be able to really trust each other if we can find trust in each other's eyes."

Whitney and I never lost trust between us, but there were times when our eyes didn't meet, to use Maya's metaphor. I do think, however, that Whitney struggled at some point to look the public in the eye. Not out of shame necessarily, but out of weariness. She tired of defending herself. She yearned for normalcy. And as Bobbi Kristina grew older, she yearned for it even more. So much so that she thought of giving up all that she had accomplished in order to be with Bobbi Kris and enjoy the everyday stuff of motherhood.

But looking someone in the eyes is a two-way affair. The public didn't look Whitney straight in the eyes either. Instead, they stared at the persona the media pitched on television and in the tabloids.

Is there a scenario where Whitney was totally set up by the media? Think about it. The very people who made her into a household name were the same people who made her into a doping diva. Those people didn't know anything about her. Even months after her death, I've seen the tabloids still working salacious headlines and conspiracy theories. There's really no way to justify what appears in the news now. And the more I think about the level of scrutiny

Whitney endured, the harder it is for me to comprehend how she survived it all for so long.

<center>⋄⋄⋄</center>

Everyone remembers the "crack is wack" interview with Diane Sawyer in 2002. We watch moments like that and immediately make up our minds: "Whitney's nothing but a junkie diva who's blowing her talent on the rock 'n' roll lifestyle." Do we ever stop and think that maybe Whitney was trying to get out of a situation? What better way to get the media and the masses off your back than to give them every reason to write you off?

After that infamous interview, Whitney fell off the map by some accounts. It's true that she didn't record another album for seven years.

She was in a dark place. And when I say dark, I mean, a place of anger. Because she realized, "Hey, y'all didn't love me. You said you loved me, but you didn't *really* love me. I'm not getting the invitations I used to get, or the respect I was afforded. What I'm getting now is the truth—that you didn't care in the first place." Her anger came from realizing how disingenuous people were.

The truth, in this instance, did not set her free. When she was presented with that kind of public sentiment, it weakened her. It weakened her in the sense that she had trouble dealing with it. And so, rather than dropping off the deep end as the media claimed, Whitney retreated. She kept to herself a lot more.

She would still call me, and we'd catch up—but I always knew when she was feeling down, because she didn't talk as much. When she was happy, she talked nonstop. During this time of seeming inactivity, she was more still, trying to get away from the light of fame.

When Whitney resurfaced in 2009, people were saying she sounded tired. In truth, she *was* tired. She was still, in a sense, recovering from the breakup with Bobby and trying to live her life on her terms. In the state she was in, she had no business being in front of a camera, promoting her new album, hitting all the big talk shows. She wasn't in good voice either. When you're known for your vocal prowess, you don't go on national television to try and prove anything if you're physically not ready.

I know Whitney was angry with her situation, but her appearance on *Good Morning America* made me angry with *her*. She had no business being on that show. When your vocal cords are tired, you have to let them rest. It wasn't drugs or whatever story people were concocting. *She* was worn out. Her voice was worn out. She needed rest.

If you want to discover why her voice was worn out, try and sing her song list three times in one day. *That* will run your voice down. She was a vocal powerhouse to be able to sing the songs she did night after night. Everything revolved around her voice.

I don't take drugs, and yet there are times when my vocal cords are *done*. People give Celine Dion a hard time about how she babies her voice, and maybe she takes it a bit too far, but you don't see her doing a lot of interviews when she's on tour, and that's intentional. The less talking, the better. The adoring public knows Celine for her vocals, not her dance routines. It was the same with Whitney. And when that's the case, you simply have to preserve your voice, for even whispering can injure it.

This is where Whitney got into trouble. She loved having a good time. She loved talking. I'd say, "Whitney, you need to stop talking and get some rest."

"Okay I will, but . . ." And on and on she'd go. She was unruly in a good way—which is the Whitney we loved—but at some point I'd end up saying, "Girl, go to bed. Get some sleep." Yet she didn't want to do that; she wanted to hang out.

When you don't sing for a long time and then you begin to sing regularly again—really singing like the professional that Whitney was—your voice is going to get sore just like any other muscle would. It's no different than working out at the gym. If you haven't regularly ridden a bike for a few years and you walk into a spin class, you're barely going to be able to walk the next day. Whitney hadn't been singing regularly, and therefore she wasn't ready to perform.

But I guess the bigger point is that she didn't really *need* to get out in public and do interviews at all. In my thinking, why give the media a bone? You're not ready, and you're not obligated to do any of it.

<center>⁙</center>

When I saw her give the Oprah interview, I became even angrier, not with her or with our friend Oprah, but with the industry. I knew that the media and the masses would take that interview and use it to sum up Whitney as a person, which to me was unfair. But that's what the industry does. In any way it can, it will try to sell you—whether it's an interview about your sex life or drug abuse or one of your songs. Doesn't matter. At some point, you cease to be a person. You represent dollar signs and your life seeps away; it becomes a transaction.

CeCe and I told Whitney that "if you can't sell an album because of your raw talent, then forget about them [industry people]." I didn't want her to do that *Good Morning America* show where she

sang in Central Park. Why? Because she had no voice. I wanted her to wait. But there again was that notion that drove Whitney—the notion to prove people wrong and to show she was in control.

She knew where I stood with it all. I loved her and wanted to see her succeed, but I wanted her to show up like the Whitney I knew her to be.

We did, however, get a kick out of the media's hype about her sudden "resurfacing," as they called it. The *I Look to You* album was supposed to be her comeback? Where had she gone? The last time I'd checked, Whitney's record sales weren't in need of a comeback.

She told me, "This ain't no comeback. I ain't went nowhere."

We laughed about it a bit, but that didn't take away her anger about the situation. It was almost as if she did those shows to tell the world, "I'm still here, and this is who I am." But for those of us who really knew her, she had remained the same person all along.

It doesn't matter who you are, you don't want to hear bad things said about you. The irony of Whitney singing the line, "I look to you, after all my strength is gone," on *Good Morning America* was that at this point in her career, she had lost much of her strength. Her voice was not what it once was because she was so run down and hadn't properly taken care of herself. She was not confident. Her performance that day in Central Park was fearful and tentative.

I hurt just watching her get through it. She wanted so badly to show everyone that she was still the same Whitney. But I don't think she needed to show us anything. I think time was working its healing magic. And we all need time, just to be ourselves.

❖

During her seven-year hiatus from the music industry, I saw a Whitney who wanted to return to the simplicity of life before the stardom. And her desire to get back to a simpler life was really her wanting to get back to the joy of God.

You and I aren't much different than Whitney in this regard. We face tough times in life, and those trials challenge the core of who we are. If we are people of faith, difficulties challenge our faith. It's in those times that we cry out for God's help, and that's what Whitney was doing when things got crazy—when her marriage began to unravel and people began to reject her. She wanted out of the world's light so she could find peace again in God's light.

Whitney was a down-to-earth kind of girl—a jeans and T-shirt type of girl. When she became "Whitney Houston," her life was not her life anymore. She was whisked away for years, around the world and back again. And I saw her—not the Whitney Houston the media portrayed, but the real Whitney—begin to wither under the stress of it all. Any celebrity will tell you that, in the thick of it, when you're making loads of cash and people wait on you hand and foot, it's good. For a time. But that time does not last. It can't; it's not sustainable.

After Whitney returned from her first trip to Paris, she told me she never really saw the city. She sang and she left. She passed through Paris because her schedule didn't allow a real visit. She was in the world, but not really *in* the world—so busy with the rigors of touring that she was either overbooked or too tired to do anything. Whitney had to sleep and stay in during the day to rest up for each night's concert, which included "meet and greets" after the show. I don't know who came up with that tradition, but for a performer to visit with fans after you've just given your heart and soul on stage wears you out. All

you want to do is go back to your bus or hotel and sleep as much as you can. Because at the next stop on the tour, the audience will want the same performer the last city got, and the one before that.

This is unimaginable to many of us. We fantasize about fame and fortune, but when it hits you the way it hit Whitney, it's a beast.

The Whitney we saw and heard in 2009 was a wounded woman. She said it herself for all the world to see: she wanted to return to the "joy"—that "peace that passes understanding"—because it alone fulfills.

Whitney was quoting Philippians 4:7 from the Bible. What's interesting about that verse is what precedes it. The previous verse says that we should not worry or be anxious about life. Instead, we should pray to God. Take refuge in him. He alone can calm our hearts and ease our fears and bring back our joy.

That's what Whitney desired. That's what she was trying to do. She was giving it all to God. She was waiting on him and taking refuge in him.

Though you can't explain this peace that is beyond human understanding, you sure can know when it's not in your life anymore. When your joy leaves, peace is hard to come by.

So much had built up in Whitney's life that she just needed to let go and cling to God. Clinging to God isn't some mystical thing. It simply means that we place our trust in him; that we go about our everyday life with him in mind, not the things the world throws at us. God promises that when we give him all our worry and anxieties, he will give us a peace we can't explain, a peace that will guide and enrich our lives.

My friend Luther Vandross used to call me as soon as he stepped off the stage . . . because it's lonely. When he or Whitney or any

performing artist steps off of the stage, they stand alone. The crowd has returned home and moved on with their lives. They've taken a piece of you with them, but you're standing there by yourself and the only thing you can think to do is call someone who knows you. That's what Luther would do, and that's what Whitney would do. She wanted to talk to her brother. Why? Because I cared about her. The real her.

Could she have called her label and told them that she was homesick and wanted to go home? No way! As long as you're making money hand over fist, you put your head down and move through your obligations. Only when you stop selling records and selling out stadiums will they leave you alone.

Those obligations and pressures never really ended for Whitney. She took herself out of that world instead.

❖

As I listened to the other speakers at the funeral talk about Whitney, and as I listened to my brother Marvin preach about priorities, the inevitable question crossed my mind: Why am I here?

I wasn't supposed to be sitting at Whitney's funeral. I was supposed to be planning her fiftieth birthday. I was supposed to be catching up with her, listening to her stories about her life and career and her daughter.

I think it's always unfair when a young person passes. It's too early. In those circumstances, only God can answer why. But to me, Whitney was too young as well. Forty-eight is not old by any stretch. Her youthfulness and her amazing talent incited questions: "Why,

God, would you allow her to be taken from us *now*?" It's when I ask those questions that I'm reminded of humankind's brokenness: broken relationships, broken morality, broken health, broken governments—all stemming from broken people.

There aren't a lot of answers to "Why?" When I ask why, I'm reminded of the irony layered into the lyrics of "I Will Always Love You," with its wishes for a gentle life and fulfilled dreams, happiness, and love most of all. Whitney's career afforded her wealth and fame beyond measure. Her dream of being a singer did bring her joy and happiness to a certain extent. But imperfect people stand at the controls in this life. The gatekeepers of the music and media empires will let you in if you have the talent. And if you're a born supertalent like Whitney was, they will push cash into your gift with little regard for the personal ramifications. But it all cost her something very dear: her privacy and the normalcy that the rest of us often take for granted.

Sometimes our dreams can lead us down a path we never thought we'd walk. They can deceive us into thinking we want something that wouldn't be so great for us after all. It makes me wonder what is really worthy of our dreams in this life.

I don't think it's wrong to desire prosperity or success. So don't hear me saying that you shouldn't dream to be like Whitney. Go ahead: Chase your dreams, and dream big. But be wise.

Jesus once advised that one should consider the cost before taking on a project—and he didn't just mean financially. The world will shower abundance upon you if and when you achieve your dreams, but it will also bury you with expectations and strip away the simplicity of your life.

Whitney missed that simplicity most of all. I think when she finally made it back into the public eye, she held her career and private life in good balance. She'd regained some of what she'd lost along the way and was pursuing the balancing elements that *really* make life worth living: family and faith.

"We are a business of such great talent but also,
unfortunately, of great tragedy."

LIONEL RICHIE

Drugs

The biggest devil is me. I'm either my best friend or my worst enemy.

Whitney

✦

*I*t pains me to discuss the topic of drugs. Think about how hard it would be to talk about one of your close friends or siblings in the context of substance abuse.

I don't have to look far to read or hear about drugs and Whitney. Those headlines come at me while I'm sitting at home watching TV or even picking up groceries. *Why?* I ask myself. I guess because people love to know the inside scoop. Yet I strongly believe there are things that should really remain among family. I also believe that there is more to the substance abuse problem in the entertainment

industry than just naked addiction brought on by the partying lifestyle.

Does that contribute to it? Yes. But such deeper issues persist, that we'd be fools to think people don't turn to drugs to cope with a world they had no idea they'd be living in. My hope here is that we'd reflect on the *need* underlying the addiction and that we'd also look in the mirror. Does condemning those we don't know look good on us? Is it for us to cast judgment on someone who's no longer with us? I think if we're honest with ourselves, our answers to those questions will guide the way we treat and remember our fellow man—and in this case, Whitney.

You hear plenty about the rock 'n' roll lifestyle—it means fast living and hard partying. And I think we all know what that includes: drugs. They're like the ugly stepsisters in *Cinderella*. They're annoying and diabolical, but no one does anything about them. Because they've somehow found their way into the elite circles in our society, we let them into the palace ball along with all the other invited guests. But they also cause us to leave the innocent, the Cinderellas, at home washing the floor.

❖

Sadly, in the celebrity world, family is usually only mentioned if yours is disintegrating: if an artist has a falling out with an overbearing parent; if a superstar couple gets divorced after mere hours together. Ironically, even though family is the one element of celebrity life to fall apart, it's the one thing that, deep down, every celebrity desires.

As I've shared, Whitney grew up with strong family ties: her aunts and cousins who were also in the music business influenced her

immensely, and her eventual marriage to Bobby Brown meant the world to her. Whitney clung to the people she knew she could trust. She realized the need and importance of family. And not just blood relatives, but the family she chose. The people who she trusted—and who I believe she would've died for—they were her family too.

So then, why the breakdown? Why did substance abuse and the rock 'n' roll lifestyle find its way into Whitney's life—a life with so much family protection? Why does it happen to so many celebrities? It's the thing we keep touching on: that celebrities are real people with real struggles and weaknesses, not these gods that the media portrays them to be.

I think Whitney would want those who cared about her to know that when the lights went off, she was just a normal girl with all the temptations and struggles that everybody faces. But that girl wasn't seen too much. Most people only saw the *other* Whitney—the one who wore the gowns and catsuits and crazy stage outfits, the one plastered all over the magazines.

I also think most celebrity meltdowns happen because of the nature of the industry. And I mean that in two ways.

One, the industry's values don't align with family values. The entertainment business is predicated on making money, creating buzz, and feeding the publicity machine. That kind of environment can chew up a person quickly and have disastrous effects on a family.

The second way, however, falls on us—the fans. We're buying. And demand drives the machine. The fan completes the circle that keeps the celebrity in and that keeps out everything else that really matters. Think about the celebrity families who go to extreme lengths to maintain their private lives. It's a battle. If you don't have a tight group of people around you who you can lean on and trust, then

you're doomed. But even then, if you're not setting up boundaries in your world, things will spiral downward.

Whitney spiraled, and the world watched her do it. Then they read about it and talked about it at work. Meanwhile, a real person was left to deal with the machine, alone and lost, while people gossiped and pronounced her guilty. Yet the truth is, everybody else is guilty to some degree too. Our need to know and our swiftness to judge is where we betray ourselves. Isn't it hypocritical of us to drag others down for their weaknesses, just because they're not ours?

I have never taken hard drugs like heroin, cocaine, or speed. I've never smoked weed or puffed a cigarette. And alcohol? Well, I just can't understand the acquired taste. But do I judge those who do? No. Because I don't know their stories. What was their family life like? Did they suffer brutal loss? Were they abused? Were they pressured? Were they extremely powerful and wealthy with no accountability? Did we ask those things about Whitney's story before we passed along our judgment?

My story is simple. I never introduced my inner man to these substances, so their temptation does not exist for me. But I have another story—a story of struggle and failure and constant temptation. My struggles and temptations may not be yours, and yours may not be mine. Regardless, neither of us has a right to boast or to look down on the other.

It's easy to pass judgment before we know someone's backstory. It's much harder to take the time to discover the reason behind their struggle. That's the only way we can truly help someone.

It seemed like the world was having a feast waiting for the coroner's report on Whitney, just like they did with Michael Jackson. As if what the authorities told us or didn't tell us was going to make a difference. We're not patient enough to understand the whole story. We're a bumper-sticker, sound-bite world. Just give us the headlines in 140 characters or less and we'll be good.

That's not fair and that's not human.

We all need trustworthy, loyal people surrounding us—people who will keep our confidences safe and be a sanctuary, providing a place where we can go and find truth. Answers to tough questions. Peace. And most importantly, unconditional love.

I try very hard to be that type of person, because to me, trust and loyalty are bedrock characteristics of any relationship. Whitney needed trustworthy and loyal people surrounding her. But most of all, I believe she knew she could go to God. And she did.

The wonderful Dottie Rambo wrote one of the songs Whitney sang on *The Preacher's Wife* soundtrack, "I Go to the Rock." ■ **GO TO TheWhitneyIKnewVideos.com TO VIEW THIS AND OTHER BONUS MATERIAL.** Now I must admit, my favorite one who sang it was the incredible gospel singer Danniebelle Hall. But it's the lyrics I want to focus on. They ask us to consider where we turn when life's difficulties arise. Then the words celebrate that we indeed have a place to rest—the Rock of our salvation: "When the earth all around me is sinking sand, on Christ the solid rock I stand."

Like Whitney, we may grow up knowing that Jesus is our Sanctuary, our Rock, our Deliverer, our Safe Place. But somewhere early in life, most of us find little substitutes that provide us temporary relief when we feel like God isn't answering our prayers quickly enough. For some, it's drugs or relationships. For others, it's food or

shopping. It doesn't take much to become like Linus, the character in the Charlie Brown cartoon who couldn't do without his blanket. Everywhere he went, he carried that blanket.

Sometimes we go a bit crazy when we don't have our security blanket. We can't wait on God, so we make do on our own. We can't make it through a tough time? We pour a glass. We're stressed beyond our capacity to cope? We take a hit. We want to be liked and accepted—because being loved by God isn't enough? We pop the pill.

This is the world in which Whitney lived. She made decisions early in her career that very much affected her later in life.

We can't remember Whitney without the sad reality of her substance abuse. I guess that's fair—though it's hard for me to admit because I want everyone to see the woman I knew in a positive and wonderful light. I only wish you and I could extend to Whitney the grace that we would want from our friends and family and our fellow man in our hour of need.

"I had fourteen beautiful years with that woman.
I can honestly say that I love that
woman with everything I am.
And I believe she loved me the same way."

❖

BOBBY BROWN
In an interview with Matt Lauer
after Whitney's death

Don't Blame Bobby

I just wanted people to know that I was his wife.
I was in love. I was crazy in love.

Whitney

꿈

Whitney never blamed Bobby for her troubles. Neither should we.

I know Bobby. I knew him even before he and Whitney began seeing each other. Like any big brother, I had my concerns about the two of them together. You don't want just anyone to take your sister in marriage. You set high, high, high expectations. The bar sits in the stratosphere regarding who you're willing to let through the gate.

Several of us close to Whitney felt the same way; this was no secret. But it's also unfair and inaccurate for anyone to claim that Bobby ruined Whitney the moment they started hanging out.

Bobby and I stood on the common ground of understanding. I respected what Bobby did in his career, as he did with me. So make no mistake, my words here are not meant to diminish Bobby in any way. I simply thought that he and Whitney were unequally yoked. I felt they would be great as friends, but not as husband and wife.

Whitney knew I didn't approve of their relationship early on, and especially their pending marriage. That's probably why she revealed her wedding plans to me in such a roundabout way.

Whitney had her assistant call me one day to ask me to fly out to Vegas just to hang out with her and CeCe and a few other close friends.

"No, not coming," I said. At that moment, I had other things to do—I just couldn't fly on a whim from Nashville to Vegas.

Then Whitney called. And it was then she revealed her true plan to me: It wasn't just to come and hang out. It was to be with her and the gang because she and Bobby were going to elope.

"Why didn't you just tell me this upfront instead of trying to trick me?"

"I know, I know. Well, we're talking now . . . aren't we? Won't you please come out?" she begged.

"No. I'm not coming, Whitney."

Because I didn't say no very often, she knew something was up. So, she spilled the beans. "Alright, let's talk."

Here is where The Pact really kicked in. We needed to talk about this because we promised we would.

"Aren't you even going to say hello first?" I chided her.

"Hi. Now, let's talk."

So, we had our "Bobby" talk.

We talked about how she was going to handle the other women in his life—the women who had his other children. I asked how she was going to handle his drinking and his use of pot. But the main issue we discussed was his insecurities. Any man—I don't care who you are—would struggle with insecurities if he'd had the amount of success Bobby did and then married into what was the phenomenon of Whitney Houston. It was inevitable that Bobby would experience a diminishing sense of self. Like it or not, his career would be overshadowed by Whitney's massive success. Would he be able to handle that?

"Don't act like that ain't gonna change things between you," I said.

She understood, assured me that everything was going to be okay, and thanked me for talking. After our conversation, I told her I would definitely be at the wedding when she had a proper one. And she promised me that if things didn't work out between the two of them, she'd get out.

<center>⋄⋄⋄</center>

When your wife makes Whitney's kind of money and you make a significantly lesser amount, that's going to cause problems. I was sure that tension would cause problems in their relationship. Couple that with a firecracker like Whitney, and you've got a combustible mix. I knew her, and I knew there'd be pressures with the mothers of Bobby's other children. Whitney had to battle that.

Not only was this difficult for her, but it placed Bobby in an unenviable position. I just didn't see it panning out.

Did they love each other deeply? Yes. But passion quickly fades in a marriage when those times of hard decision come. How would Whitney respond when Bobby needed to be there for his other children? What kind of pressure would that place on Bobby? On the marriage itself?

Those were the types of questions I tried to get Whitney to think through.

I wanted better than the best for her. I wanted her to be with someone who would love and respect her for who she was, not for who she'd become. I wanted her to see the whole situation and think through the realities of it.

That's what family does: they protect. And Whitney knew that about me. That's why she kept their idea to elope a secret until she could no longer hide it from me.

Again, in all this, you don't hear me saying that Bobby isn't a good guy. He was just not the guy I saw for her.

What frustrates me now, and especially in recent years—with their 2005 reality show and all the escapades that ensued—is how the public judges Whitney (and Bobby too, unfortunately) solely on their marriage, which unraveled so publicly.

Was it the best idea to do the reality show? No. But people need to understand, that show was supposed to be about Bobby's career, not Whitney's. People remarked that even though the show was about "Bobby's world," Whitney received as much, if not more, camera time than he did.

Of course her fame eclipsed the show! Her fame eclipsed many things! But fame can't eclipse the way the public views you. Instead, fame inflates the public's view of you.

I think the show was a bit of a wake-up call to both of them.

Being Bobby Brown thrust their marriage into the public eye. As a result, this intimate relationship that should be kept private was broadcast to anyone wanting to watch. Right or wrong, it further tainted Whitney's professional persona and cast Bobby in a negative light as well. In essence, everyone watched their tumultuous relationship fall apart. And we don't like stories if they don't end in "happily ever after."

Things change when you get inside a marriage, when you have a child, when you attain massive success. It's that change that threw Whitney, I think, and probably Bobby too. It's that change that drove her as well.

·❖·

At the funeral, so many memories were going through my mind. Like the day of her wedding. No, they didn't elope after all. They did it properly—at her New Jersey home, with 800 guests attending the reception—and it was magnificent. Whitney asked my brother Marvin to officiate, and CeCe was a bridesmaid.

About two weeks before the wedding, Whitney called me. "I need you to write a song for the wedding."

"Oh, okay. I'm just supposed to pull a song out of the air, right?"

I put up a good front, but I wrote the song and loved doing it. Then I sang it at the ceremony.

"Enough Said" was the name of the song. Everyone was predicting that Whitney and Bobby's marriage would never last. So I tried to encourage them both with a song that told them to stop worrying about the whispers.

I thought that "Enough Said" encapsulated both Whitney's and

Bobby's personalities. They knew what everyone was saying, but you know what? Enough said.

The lyrics go like this:

What can I say?
On this your wedding day?
Can a wish come true?
I love you so
With all my heart
So, I penned this song for you

You just live your lives, make God the head
You will learn, with time, in spite of what some said
You will be just fine, and, enough said . . .
Feelings come and go, it's a marriage trait
Love will only grow if you communicate
Remember the vows you've pledged
And, enough said

But let me say one more thing
There will be those days that are filled with night
You will question if, if this love is worth the fight
Sometimes love you'll dread
But, enough said

⋅⋅⋄⋅⋅

When the outside world and even her closest friends told Whitney that her marriage didn't stand a chance, did people not expect her

to react? You can't say something like that to someone who's as driven as Whitney was, and who has achieved such a high level of professional success. It just made her all the more determined to prove everyone wrong.

For Whitney, even when things between her and Bobby got out of hand and seemed to escalate to a point of no return, there was within her a switch that did not allow her to quit. She stayed, not because everything was great, but because she wanted to silence the naysayers. She wanted this as much as she wanted the relationship.

In the end, their "us against the world" mentality is what kept them together as long as they were.

I believe Whitney truly loved Bobby. He was energetic and real and gave her life a tangibility she longed for. He was an adventure for her, and she loved him for that. They had great chemistry.

Despite that very real and deep love, though, how could the marriage stand up to the pressure of everyone looking on and saying, "It's destined to fail"? You try to overlook the bad and wish it away; you want to prove that it was right and that you were right, but it doesn't always happen like that.

And compounding everything was the reality of Whitney's life. People need to realize the challenges and tensions that entered in when Whitney married Bobby. They married on July 18, 1992. Later that year, *The Bodyguard* released. Then, on March 4, 1993, Bobbi Kristina was born. And as the phenomenon of *The Bodyguard* kicked in, the movie and the soundtrack consumed Whitney's life for the better part of three years.

From the outset, Bobby and Whitney were thrust into an almost impossible situation. Whitney later admitted that her substance

problem began just prior to *The Bodyguard* and her union with Bobby. So the tension in Whitney's life was unbelievable.

And then Bobby became clingy. When *The Bodyguard* craziness ramped up, you could really see his insecurities come through. He'd been a key support for her during the filming of the movie, urging her almost daily to not quit when her own insecurities threatened her confidence. As she reported to Diane Sawyer, he told Whitney, "If you quit now, you're going to blame me for the rest of my life. You're going to do this movie and . . . do it well. You can't quit now."

But as time went on, things changed. He would walk out on stage at the end of her concerts, when the throngs of people were going crazy for her, and hug her. Her spotlight never turned off, while Bobby's was steadily dimming. To his credit, Bobby continued to help Whitney as much as he could through this time. While he was helping her, however, his own star was fading. And that presents another tension in a marriage.

I spoke to her about this—about Bobby going on stage and hugging her—and told her it needed to end. "Everyone knows you're married," I said. "They don't need to see all this stuff going on."

There were signs to me early on that they were in trouble. But so what? I think everyone understands they weren't set up to succeed. Their stars collided, literally.

That's also in the past. What we need to realize now is that Bobby and Bobbi Kristina need support and prayers, not more rumors and gossip about Whitney's past or Bobby's tainting of the Princess. These notions are overblown.

I love what Michelle Obama said in *Ebony* magazine upon Whitney's passing: "Now is the time we need to pray for [Whitney's] family, in particular her daughter, Bobbi Kristina. . . . We all have to

wrap our arms around that young girl and send her all our love and prayers and support and hope that she gets through in one piece."

Whitney was a big girl. She made decisions that were not the best, like every single one of us. If she were here today, she would claim it. The truth is that we all have made and will make wrong decisions. The only difference between our decisions and Whitney's is that hers played out on the world's stage. Our responsibility as her friends, and even as adoring fans, is to allow the grief process to run its course and let people heal; allow her memory to shine through the dark times and finally let her rest.

"No words. Just tears."

RIHANNA
In a tweet after hearing of Whitney's death

Pull It Together

Do what you do.

Whitney's frequent words to BeBe

⁓

February 18, 2012. I crawled out of bed and looked at what I was about to wear. I had picked out my suit days earlier. It was pressed and properly tailored, just as my mother had taught us as we were growing up.

Mom always told us to dress appropriately for the occasion. You tend to wrinkle your nose at such notions when you're a kid. Yet now that I'm grown, it turns out that I like dressing for the occasion. On stage, I like to keep it tight and tasteful. At home, I like to be comfortable.

There's something about dressing your best. But this day was different.

I eased into my shirt and straightened my sleeves. My cufflinks turned and fastened, I was getting ready for a Whitney event. Only this was one I never expected to attend: her funeral.

To compound my sadness, there was no one to call, no one to joke with, about what colors they were wearing on this Saturday morning. There was only the quiet of my room and the song—or *songs*, rather—piling up in my head. And all of them were Whitney's.

At some point, I knew that those songs would spill over from my head to my heart. When was that coming?

I slipped into my suit jacket and made my way down to the car. This was her last event. This was the last time I would dress up for Whitney. I wanted to look good, but I didn't want to care about looking good. I wanted to be able to take off the suit and have this particular event go away.

Everything about that morning reminded me of her. Even my cufflinks. Because even my cufflinks mattered to her.

<div align="center">❖</div>

The world will remember Whitney. They will revel in her voice, they will deconstruct her public and private lives, and they will marvel at her beauty. They will make a big deal about how stunning she looked and the custom outfits she bought from top fashion designers. I suppose all that is valid. But hidden in the glitz and glamour is Whitney's voice. Her other voice. The voice that spoke to me in clothes.

"What you wearin', my brotha?"

"No, no. What you wearin', my sister?"

She and I spoke in clothes.

Whenever I would attend one of Whitney's events—a concert or awards ceremony or whatever—Whitney and I always checked with each other about the clothes.

"What you wearing?" she'd ask.

"Sis, don't you worry about it. You'll see when I get there."

Then, at the event, she'd remark, "Oh brotha, you lookin' fine!"

It might sound funny, even superficial, but clothes were a common language that we both enjoyed.

The magazines and television media kept close tabs on Whitney's flair and fashion. It was part of the gig. *Millions will see you; you'd better look like a million bucks.*

And she did.

⋆⁂⋆

Into the car now. On my way to the funeral.

Funerals are just events. You get dressed in your best, drive to the site, and go through the motions—simultaneously numb and yet thoroughly present. Meanwhile, the birds still sing. Traffic still hums. Kids play on the playground—their world unaffected the way your world is affected.

The world moves on and forgets. That morning, however, I wanted time to stop, to rewind.

As we drove to the church my heart grew heavier. And even though the car kept moving forward, time—in a way—did rewind in my memory. The moments before I would step inside Newark's New Hope Baptist Church pressed on, while my mind went back and remembered.

Soon other minds and voices would remember too, recalling to each other—and to a watching world—the person we loved. We'd dress her up in our loveliest thoughts and hear her sing one last time. The Whitney we knew. The Whitney we could never forget.

I recall how Whitney loved dignity. She loved the dignity and confidence that accompanied a person doing what they do best. It was something she knew like few of us do. When she sang, her confidence freed you to enjoy every nuance of the song. She took pride in her craft; she brought a dignity to it.

In the scheme of that morning, I could still hear Whitney telling me, "Now, pull it together, BeBe. Don't mess this up. Don't embarrass me! Stop thinking about me and do what you do."

That was a common refrain between her and me. Before a big performance, we'd call each other and our pep talk challenged us to bring honor to our names and to the songs and to the event.

When I finally arrived at the funeral, I stepped out of the car and stepped in line like everyone else. But I was ushered in because I was singing. Once inside the church I saw Robyn Crawford, made a beeline for her, and hugged her. Robyn was there from the beginning. When I met Whitney, I met Robyn. And we loved each other instantly.

Then, there was Aunt Bae. She always cooked for us when we went to Whitney's house, and she traveled with Whitney for years, preparing home-cooked meals for the niece she loved. I hugged Aunt Bae. I knew her pain was heavy, heavier than my own.

I noticed people who represented different types of relationships. Some were dignitaries, and they reminded me of Whitney's broad stripes—how she knew and touched so many different kinds of people.

"Pull it together," I kept hearing her tell me. I strolled through the mass of people and considered how each carried their own grief. "Pull it together, brother!"

Finally, when I stood up and began remembering her out loud, I felt like I was standing in someone's house. I felt like the family had gathered, to remember.

It was as if the sanctuary was a huge family room. Once you're all assembled, and it's time to do family business, everyone sits together. Though there are some people you love and others that you don't really like—still, they're family. That's the defining dynamic.

I could see the loved ones and the not-so-loved ones, *all* in the family room of that sanctuary to "get it together," to say our best good byes to Whitney.

-:::-

I'm moved by it—*something* moved me. It moves you too.

It was always ringing in my head. It was in her. It was always in her. Was it her voice? Or was it something much deeper?

I hear Whitney's cousin, Dionne Warwick, call me up to the church's stage there in Newark, and I remember it was Dionne years ago that called Whitney up to the stage at the Grammys. That was Whitney's first Grammy—the first of many. That was Dionne introducing the world to the girl I knew as my friend. That was when Whitney first hit it big, singing "Saving All My Love for You."

Dionne opened the envelope on that night and called her name, and then started leaping because it was Whitney who won. America's rising star rose from her seat, decked out in her red dress, approaching the stage. The two embraced. What pure joy!

Now, however, the tables are turned. Dionne isn't calling Whitney to the stage. In fact, nobody will ever call Whitney to the stage again, except in singing one of her songs. Dionne was there when Whitney became "Whitney Houston"—knew her long before she was *the* Whitney Houston—and now she was sharing her cousin with the world, because Whitney was so much more than her celebrity.

That "so much more" is the reason I am sitting in a pew on this gray Saturday morning in February, listening to people talk about her. Suddenly, in death, everyone wants to hear about the *real* Whitney. What should I say?

⋙⋘

I am heading up to the stage. But this time, I'm not standing in for Whitney at an awards ceremony because she couldn't make it. I'm eulogizing my friend. My sister.

I had hoped Dionne would skip my name. No such luck.

When she finally calls for me, I want to turn around. I want to sit back down. Maybe if I don't ascend the platform of that church—if I don't say or sing anything—I will wake up and Whitney will come walking down the aisle yelling, "Family!"

That's what she'd done several years earlier when my brother Ronald passed. He was forty-eight when his heart failed him—the same age as Whitney when her heart gave out.

At the time of Ronald's passing, my entire family gathered to remember him. He and I were closer than close—he was my best friend. And it was a time of hurt and unspeakable pain. How do you cope with losing your brother and best friend in one tragic moment?

The bond shared by my family runs deep. Losing Ronald made that bond quiver.

On the day of Ronald's funeral I ascended the stage to speak about my brother. I had just finished singing "Tears in Heaven" by Eric Clapton, adding some lyrics to personalize it in Ronald's remembrance. I was in mid-sentence, speaking from the heart about what my brother meant to me, when the door opened.

In she walked. Or burst, rather. She blew in with the Detroit wind, waving her hands and shouting, "Family! I'm here, family!"

Oh, Whitney. Are you kidding me? Lord, here she comes, I thought.

But that's who she was. The family bond quivered all the way to her heart, and there she was—oblivious to social protocol, focused on Ronald . . . and on us.

It wasn't Whitney wanting to grab the stage. It was my gospel-music sister wanting us all to know that the family was accounted for and that she was there to grieve. She was there to celebrate Ronald's life. She was there to sing.

Singing would ease the pain. Singing would heal. Singing would . . . well, it would do what normal words could not do.

Whitney knew that. She lived it. She embodied it.

"Family! Family, I'm here, family!"

Yes, Whitney. You're here. *Be* here.

"When people see Whitney Houston, they see her as such a superstar, and they sometimes think that's all there is to her. But she's somebody's child, and she's somebody's mother. There are . . . people who knew her intimately and really mourn the loss like anybody would."

❖

Bishop T. D. Jakes

Pesky Grief

When I think of how young and full of life Whitney was,
it kills me that she has passed.

BcBc

❦

After my brother Ronald passed, I saw a grief counselor.
When Whitney died, I remembered what the grief counselor, Marilyn, told me: "Singers and artistic people tend to love deeper than most people."

Now that's not to minimize other people's love; it's just acknowledging the simple fact that people who make their living by delving into their emotions tend to react to hurt, pain, and loss in a more visceral way. That understanding gave me freedom in

grieving for my brother. I didn't suppress thoughts and memories; I let them come.

But grief can be tricky. It can place you on its island. Next thing you know, you're keeping to yourself all the time and not expressing your grief to the ones you love.

Marilyn said that we in the West get it wrong. When she lived in East Africa, the community would come together and sit with one another—the whole community—and just *be* when someone suffered a loss. Sitting there. When the grieving one cried, the village cried with him or her.

Sitting in a pew at Whitney's funeral, about to take the stage, it struck me how this must have been what it was like in East Africa. Whitney's community had gathered—in a church, no less—to cry and remember together. I felt like, finally, we were getting it right. Not just within that sanctuary, but even beyond those church walls. I just wish it hadn't taken her death for us to do so.

<div align="center">⬧⬧⬧</div>

There's no question that death shows us who knew us and who our loved ones are. It shows us who we touched and who we alienated. Unless you're Whitney Houston. Then the world converges and mourns your talent more than you the person.

Most of the world only saw glimpses of Whitney, but I was so thankful for the list of people who spoke at the funeral, because the real Whitney could—at least for the briefest of moments—be seen by everyone. And that's interesting, because Whitney wasn't just a diva songstress who blew the doors off the pop music world. She was a quirky woman with a little-girl gleam in her eye. That same

kind of gleam you see in a child when they know they're up to something mischievous.

Spending Easter Sunday with Cissy after Whitney's death was something special and private. We attended church; Cissy sang; a choir accompanied her, as did another vocalist. I sat in the pew and listened. To a gospel legend sing? Sure. But more than that, I heard a grieving mother sing of hope, of faith, and the blessings of God.

Cissy and Bobbi Kris knew Whitney best. I like to think I knew her well. Still, you and I only know those closest to us as much as they are willing to let us in.

Spending time together is necessary if we are to disclose our true selves. But we must go farther still. We must let our guard down and live in a way that invites people to know us. Fear can't exist in our truest relationships. Love casts out fear; love empowers us to be confident. And confident relationships breathe life into us.

My relationship with Whitney was a breath of life. We spent real time together. And when I say *real*, you may be thinking, *Well, what other kind of time is there?* What I mean by *real* time is the kind of time where the point of being together was encouragement and fun.

As I said at the beginning of this book, I saw Whitney relax. I saw her cry. I saw her nervous. It's those authentic glimpses, shared in everyday moments, that move us toward deep and abiding love.

A friend of mine once told me that to abide means to wait on those we love, like a serviceman who leaves his wife to go to war. The wife abides in his love—she waits for him. And all the while, their love grows.

I think of my kids and how I want my love to be an abiding kind

of love. The kind of love that is patient with them and that nourishes them as they grow up and go out into the world.

This is the kind of love we need to cultivate in our relationships with our friends too. An abiding kind of love in a friendship builds a foundation of trust and loyalty, of solidarity and honor. Maybe this is what Cissy was referring to when she said—upon hearing that I was writing this book—that I *knew* Whitney. Maybe she was saying that her daughter and I enjoyed mutual trust and loyalty—a friendship-kind-of-love that picked up where it left off when proximity and fame made real-life hang-out time difficult.

Now that we are in this long season of grief, I want to lovingly abide in my remembrance of my sister Whitney—and in my love for the family she left behind.

In America, we think we have to say something when death comes. But it's not about us; it's about the person experiencing the loss. And when we lose someone who is younger, like Whitney, it makes it that much harder.

People say things like, "She died too soon," or "What a waste of life and talent." But grief brings with it the muck of life, and because of who Whitney was, our culture believes it's necessary to sift through the cause of death, to dredge up her history and her mistakes. All this dredging can make it more difficult for those who were close to her to get through the muck.

Grieving people need the community—their friends, acquaintances, family—to use fewer words and to give more time so that the bereaved will not be alone. We think it's about a funeral service and a nice card and then life goes on. Life might go on, but words dry up. Loving actions, however, remain.

Grieving Whitney has been rough. But let's not forget those in her immediate family. It's Bobbi Kristina who needs our love and prayer support right now. It's her mother and brothers who need lifted up by the community. Because they have suffered this loss most of all.

"The best way to honor her is to be reminded
that tomorrow is not promised to any of us.
So love God, and love each other."

❖

CeCe Winans

Embrace the Pain

> It was singing that made us feel closer to her. . . .
> It was singing that helped us embrace the pain. . . . And so, we sang.
>
> BeBe, speaking of his and CeCe's tribute at the funeral

⊱⊰

n 1997, Bill and Camille Cosby lost their son, Ennis, in an act of senseless violence. Some time later, Oprah Winfrey sat with Camille for an interview. In their candid exchange, Camille told Oprah what one of her dear friends, a psychiatrist, had said to her. It might sound a bit harsh coming from a friend, but it was what she needed to hear: "Camille, you are going to have to go through the pain. It's the only way you are going to heal. Go through the pain."

Going through or *embracing* the pain helped Camille cope and stay focused on life amid such a time of deep sadness. I'm following the same advice by writing this book.

In a very real way, this book helps me embrace the pain of losing such a close friend. Embracing the pain helps me work through my feelings—hopefully to emerge on the other side of it all, better equipped to say good-bye even though I'd rather not. This book has served as my therapy.

I can't imagine how Cissy and Bobbi Kristina and the rest of the Houston family are dealing with their pain. It's not a process to be hurried through, that much I know.

Even as I write this, Cissy is still processing her daughter's death. She longs to make right some of the outright lies that were spread about Whitney—the types of things that Camille Cosby endured when the public peeks into the private lives of people just because they're celebrities, and then the media provides commentary without personal knowledge of the situation or the very real people involved.

At the time of Ennis Cosby's death, an extortion case surfaced. During this awful time, the Cosbys had to deal with those allegations in the media spotlight at the same time that they were trying to come to terms with their son's shooting death. Their private lives were abused. That's what our culture does to those in the public eye. If you're popular and gifted, prepare yourself to have complete strangers pry into your private life.

It's tough to embrace the pain when you're not left alone to do so. As long as the media continues to stir up stories related to the tragedy, how do we expect family and friends to move on?

There's great wisdom in the advice to embrace the pain rather

than trying to circumvent it. The opposite of embracing is running away from something. If you're not running toward someone or something to embrace, then you're either stagnant—stuck in the same place—or you're fleeing in the opposite direction. Only bad things happen when we run from the harsher realities of life. Running means that you don't or can't deal with the situation. It means the situation has *you*.

As I embrace this pain for myself, I feel like I can bury my face in it; squeeze it hard and let some of my frustration and confusion and disappointment and anger out. When we embrace someone, we usually only do so for a short time—we may linger a bit, but we eventually let go. The embrace fills us with peace and assurance of the other person's love and friendship. We can then sit next to them and just *be*.

<div style="text-align:center">❖</div>

Right after the funeral, CeCe and I were scheduled to sing at a college in Brooklyn. The promoter was very kind and gracious to us. When Whitney passed, he contacted us and told us that if we wanted to cancel, they'd understand. But we went ahead with the concert and it went great.

We doubted that we'd be able to make it through emotionally, since it was on the same day as the funeral. But being there and singing for the student body was comforting. It helped us embrace our pain. They were gracious to us as we talked with them, and we felt safe and understood.

On that day of grief and remembrance, CeCe and I put Camille's words to work for us. We sang in Whitney's honor and claimed grace

as a way out of the pain we were feeling. You see, there's always an escape hatch in our private rooms of pain. Usually that hatch is grace in the form of a memory that comes to mind, giving a little joy. Or grace can come in the form of beauty, or the simplicity and innocence of those childlike qualities that endear a person to us even when they are grown.

Like Whitney's laughter. I'm sure it was the same when she was young, but when she'd laugh, total glee came across her face. The world would see that glee when she sang—sometimes she'd almost half laugh while singing. I think because it made her so happy. She felt God's pleasure, and she almost couldn't contain it.

Laughter is one of the saving graces in life, providing an escape from the darkness that so easily entangles our world and our everyday affairs. But laughter coupled with song, well—I think that is one of heaven's highest graces. Though singing and tears can be a powerful remedy, singing with laughter is greater because it leads us into joy.

In this particular loss, it is about the joy of a person's memory. We see Whitney sing and we see the childlike laughter in her eyes and we say, "Yes, Lord. That's the grace I seek!" Whitney possessed that grace—the grace of song and laughter. What better grace to ease the pain?

One of the reasons I could talk so long on the phone with Whitney was because she'd inevitably have me laughing about something even if it was not a laughable situation. I remember after the atrocity of 9/11, a rumor surfaced that Whitney had died. So I called her.

"Hey, Houston."

"Hey."

"Well, I guess you didn't die. There's some rumor about you being dead."

"No," she said, "I ain't dead. Unless I'm talking to you from heaven above!"

It was much harder to laugh at those memories on the day of her funeral. My thoughts went from, *What will I say in her honor?* to the real world that kept humming by. The real world that we must always climb back into, whether we want to or not. On that day, CeCe and I re-entered that world with a song. ■◀ GO TO TheWhitneyIKnewVideos.com TO VIEW THIS AND OTHER BONUS MATERIAL.

It was singing that made us feel closer to her. It was singing that drew us together in our spirits. It was singing that helped us embrace the pain. It was singing that quelled the cries.

And so, we sang.

Whitney would have done the same. She would have fired up the band and sung a gospel song. She would have looked to the Jesus she wasn't ashamed of, the Lord of her life. She would have laid the sacrifice of her voice on the altar of healing and made amends. And so we sang. It felt good and heavy at the same time.

But eventually the songs end and the music falls quiet, the friends go home and the stage lights go off. Whitney's stage lies bare now, though her recordings continue her memory. It is funeral Saturday, and I'm walking across that stage now, trying to hear her echo. It comes in hushed tones—there it is. I can hear it now. Can you?

It's the sound of a sister, a friend, a fellow human being. It's the echo of her life, that precious life. It sounds like yours, I'm sure. It sounds like mine. It's the beautiful life-song each of us carries with us daily.

"Hello-o, my brother. Do you have some time to-o-day? Can you come on by?"

"Hello-o, my sister. Hello."

As we sang our hellos in life, now the echo of her voice carries on. On the day of her homegoing service, I returned her hello-song with a song of my own. Now that tribute song is the life I live from here on, after she's gone. It's the beauty and lessons I take with me that came from knowing her.

"Whitney knew how to be a star,
and she was one of the brightest stars in the universe."

❖

ARETHA FRANKLIN

To the Young and the Hopeful

I believe the children are our future.

Whitney, singing her hope

⚜

*I*t's always the same crew. You receive your invitation, you show up, and you hang with a lot of the same people. There are always new faces popping up, but for the most part, the people who attend these parties have been around for a while. It's like a club.

I'm talking about the Grammy parties, before and after.

Each year there's an opportunity to go and see old friends and to network a little and go home. The world reads about these parties in magazines and gossips about what everyone was wearing and

who showed up with whom. It all gets rather inflated, if you ask me, though I'm thankful to have attended many of the parties and have made some amazing friends over the years.

But people need to understand that the Grammys are just an event. They happen once a year. Yes, some celebrities throw expensive parties. Yes, I'm sure some of the parties get a little out of hand. But after it's all said and done, when the awards have been given and everyone says their good-byes, normal life sets in rather quickly. There's laundry to fold and kids to pick up from soccer.

It's crazy to me that our culture makes so much of our accomplishments—with red-carpet shows, fashion shows, the who's-escorting-who watch, and the who's nominated shows. Our culture loves to turn award ceremonies into events that immortalize other human beings. I can see the allure for the public, and I can certainly understand what makes some people pursue the fame that goes along with singing and acting and the arts in general. But there comes a time when we all need to step back and take a reality check.

In light of what happened with Whitney, I would be remiss if I didn't take this opportunity to give a word to the young and the hopeful among us who aspire to be performers. What would I say to them? I would say the same thing that Whitney would almost certainly say.

First, take your time.

Let me quote Whitney herself here, from an interview she did with *Upscale* magazine: "I started out working in little nightclubs—sometimes getting paid, sometimes not—sometimes performing for 200 people, other times working in front of ten. Today, it's like people just want to jump out there and immediately become stars,

but it takes time and it takes not giving up. It takes believing in one's self in spite of negativity and what people say."

We live in a society that is instant. If we want ice cream, we go get it. If we want a new dress, we go buy it. A new car? I'll go lease something right now. But there's a price to be paid for the instant economy of our day: it leads to a sense of entitlement. Young kids think they can and should have something just because it's there and seemingly accessible. In the realm of entertainment and the arts, the Internet has helped foster this type of mentality. Who will be the next big YouTube star? Everybody deserves their fifteen minutes of fame, right?

When a young person does make the big splash, the media machine kicks in and there's a relentless push to get their names into the various media outlets. Whitney was seriously performing in her mid-teens, but didn't sign with Clive Davis until she was nineteen, and didn't release a record till she was twenty-one, even though she'd already sung on television and with her mom at Carnegie Hall. Cissy and John and Dionne played a vital role in Whitney's formation, not letting her get exposed to the business too soon, requiring her to graduate from high school first, and bringing her along slowly. Then Clive groomed her for two years before she released her first album.

But in Whitney's case, even great mentoring was not enough to put the brakes on the media machine that cranked into high gear once her talent was heard. Not everyone is a Whitney-type talent. But the machine seeks to make everyone believe that so-and-so is the next Whitney or Celine or whatever megastar you want to plug into the equation.

Even though loving friends and family mentored Whitney, she

still fell victim to the *speed* of fame. Her meteoric rise shattered her youthful reality. What can ready a person for the immense loneliness of fame at an age when you should be going to college football games and hanging out with friends? Suddenly Whitney was flying all over the world and appearing all over the television—and it never stopped. Literally.

When my phone would ring at 1 a.m., I knew it was Whitney wanting to talk. She was reaching for some semblance of normalcy, a break from the hyperreality she had to endure.

Is that what young people desire? To be on a jet headed to London, when all their friends are laughing and enjoying the things in life that take time—like relationships and education and a mature faith? While Whitney's friends were going to school and getting married and working 9-to-5 jobs, Whitney was signing business deals that dictated her life.

People say, "Well, if it got so bad, why didn't she just stop singing?" Because when you sign a contract, it runs your life. You are obligated to produce a certain amount of records and to support your records with touring. If you don't produce, you could get sued. That's a lot of pressure for a twenty-something girl from Jersey who a few years prior was delighted just to sing in church.

To put some real skin on this, two years ago I went to the Grammys. CeCe and I were nominated. I ended up going to a couple of parties before the awards ceremony, but didn't attend the actual event; neither did CeCe. (A friend called to tell me we'd won.) Prior to the event, however, I was headed to my hotel lobby. I hopped in an elevator with Bobbi Kristina. There she was, a beautiful teenager all dressed up and ready to hit the town.

"Do you like my dress?" she asked.

"Yes, but where's the rest of it?" I responded.

She knew it was a bit short and tried to pull it down.

"I know, Uncle BeBe, I know."

I love that girl—she's a beautiful young woman and is going to do great things. But my heart goes out to her and the kids like her who see the world of the superstar and want to emulate it and even pursue it. Bobbi Kristina has a great head on her shoulders and right now is still dealing with a stunning loss. But when I think of my own kids and Bobbi Kris, my siblings' kids and the kids out there reading this book or watching all the music videos, I just want them to ease off the pedal. Slow down. Live a little. Be a kid for a few years.

Whitney would tell young people that, yes, the future rests in your hearts—the world will go forward with you—but don't be in a rush to get to what lies ahead. Whitney had to catch up to the speed of fame. She had to make the transition from being a "person" to being a "personality," as she once put it to *Rolling Stone*. Suddenly she wasn't a young woman with thoughts and feelings; she was a transaction, a business, a client.

When you see yourself being bought and sold—when you find out that record executives are making back-alley deals, pawning your wares like you're a traded commodity—something happens. You begin viewing yourself as someone that is beyond "the real." Not in a prideful way necessarily, but in a way that removes you from the world that everyone else lives in.

Whitney would tell you, the young and aspiring artist, to be careful not to be duped by what you think the entertainment industry wants. Living by their expectations only leads to hurt and emptiness. Don't be naïve and think the music or movie worlds desire intimate relationships with their talent. At best, those industries have a

platonic relationship with the artists. If you let your heart be open to what the industry wants, it will get twisted.

Take your time. Take your time.

❖

Second, learn to be selective.

I grew up eating Jif peanut butter. I still remember their commercials: "Choosy Moms Choose Jif."

When success in the biz comes, it inevitably opens up doors that you never thought you'd be able to walk through. Suddenly those doors are swung wide open. But just because the doors of opportunity swing open, doesn't mean you have to walk through them. Whitney eventually learned how to say no to people who wanted things from her. I can't stress how important it is to learn how to use that little word: no. Go ahead, say it—no. There is wisdom in no.

There's a proverb that says, "The wisdom of the wise keeps life on track; the foolishness of fools lands them in the ditch." No one wants to end up in a ditch. And we won't if we learn how to discern life as it comes our way. We need to be like the choosy moms—we need to develop some standards. We need to know that there are some things we just won't do. And when I say "we," I don't just mean the young people who long for fame. I mean, we the parents, we the gatekeepers in the industry, we the extended family members. We can't expect a young person to make the tough decisions on their own. We need to give them permission to be kids, both innocent and wise.

❖

Third, seek wise advice.

It all starts with "the grab"—a cute little song with a great hook. It goes viral on YouTube. Then it's a single on an album. Then the album explodes and sells millions of copies. But the cute song is not enough. What's next? What's the next level? Well of course, we need to push the envelope and show the young star coming of age—understanding their sexuality and expressing it all over the stage, right?

Give me a break. The entertainment industry specializes in stripping young talent of its innocence. Strategists whisper, "We need to keep the buzz going. You need to do _____." Young entertainers receive advice from all kinds of people telling them to perpetuate the momentum. If they do, it will produce more sales and more money, and the fame begins to steamroll. Have we no shame that we would tell young people to do whatever it takes to get a media grab?

We look at Britney Spears, who started out as a Mouseketeer on the Disney channel, and we shake our heads. "That girl just went off the tracks." Remember when she shaved her head and was caught by the paparazzi in some not-too-flattering poses in public? We write off someone like Britney, saying she's not a good person; she's volatile. But what do we expect from these young ladies who were thrust into fame so quickly? Britney had incredible success early in her career (and she is still successful). But the next thing we knew, she was expressing *all* of her sexuality in her music and videos. The innocence lingered for the briefest of moments but eventually gave way to inappropriate behavior.

Here's my question to the entertainment industry about the young stars on the rise: Is it ever enough? Do we always have to

push things to the next level? Can't we help out these young people by giving them sound advice about life and the rigors of the business? Can't we begin programs of accountability while these young people tour the world?

As a father of two talented teenagers, my prayer for them is that they will encounter people along the path of life that will take a genuine interest in them as human beings—as people. Whether they pursue the performing arts or robotics, I don't care. What I do care about is that they enter into real life with their eyes wide open, and that those who have gone before them will come alongside them and show them the pathway to success, not destruction.

I think wisdom gets a bad reputation. Most people think you gain wisdom by learning from failure. But wisdom can keep us from making the mistakes that can hurt us in the first place. The wise man learns from the one who's fallen *and* when he falls on his own.

Whitney and I both experienced death in our lives. Whitney lost her father in 2003. At the time, there were some fractures in their relationship. For years her father managed her affairs, but that ended abruptly. Before he died, however, they reconciled their differences, and through forgiveness, she learned how to let go of whatever was between them.

She had the freedom to talk with me about whatever was on her mind. If she needed to talk crazy or even foolishly, there was room for that. In that freedom, she shared with me about some of the decisions he made that she didn't agree with, but she also remembered his decisions that made her life better. At some point, Whitney became more independent and wanted to make her own choices. All it takes is one flare-up, one confrontation of wills between daughter and father, to spark a separation.

She didn't want, and she thought she didn't need, fatherly advice from a management point of view. Did she want the availability of her father as a father? Yes. She wanted to be able to go to him for fatherly advice, but the time for management advice came to an end.

She shared how difficult it was for her to let him go as her manager—something the outside world didn't hear. All the world saw was their separation. Whitney knew I could relate because my brothers endured the same thing: they also had to let our father go as their manager.

When Whitney and I saw a new artist hit the scene with a parent as their manager, we knew it was a ticking bomb. That was a fun topic to discuss, because we had both lived through it. Some advice to young artists: don't hire your mom or dad to be your manager; chances are, it won't end well.

I know that at the time it seems great—a "the family's all here" bonanza. But seriously, it places an inordinate strain on the relationship, and in extreme cases, it can cause irreparable damage. For Whitney and her father, he became offended when she wanted to make decisions on her own. I can see it now from a father's point of view. I can understand her dad feeling slighted. But the best thing, in my opinion—and it was Whitney's opinion as well—is to love your family by not hiring them.

"She was giving, sentimental, and so much fun.
We lost a beautiful soul. "

❖

ACTRESS LELA RACHON

I Will Always Love You, Whitney

You know what I used to do, Diane? I would close my eyes . . . and I'd sing.
I was so afraid when I'd sing. Then when I would open my eyes,
the people would be what we call "Holy Ghost fired out."
They would be in such a spirit of praise, I think I knew then
that it was an infectious thing that God had given me.

Whitney to Diane Sawyer

⁂

By now, maybe you've moved on. Maybe you've filed Whitney away in your mind. In that same file are names like Michael Jackson, Luther Vandross, Dick Clark, Levon Helm, Kurt Cobain, or Donna Summer.

For so long, pop culture icons live on the "screens" of our lives,

but never within the fabric of everyday life. Sure, you may have Whitney's songs on your iPod, shuffled in a playlist. But that's where it ends. And that's true for most people.

Another talented person will come along and make us forget all about Whitney. Until they try to sing her songs, that is. When that happens, we'll quickly say, "Well, she's good, but she's no Whitney." That is a type of honor we pay to the truly talented among us. But I think Whitney would tell us that the public needs to ease up. If she was still with us, she'd say, "It's fine to love my voice, but help me find room to be *me*."

Maybe that's not part of the game. I'm not naïve enough to think that a book will change the way the industry does business, though it might change a few minds. My words might linger on the consciences of some thoughtful individuals who realize that our humanity is our greatest gift. If that happens, then I think Whitney would smile. I think she would say, "Thank you, Lord!" and throw her head back like she was leading a gospel choir in church.

So much of Whitney resides in her music. In the early days you could see the anointing she had in the sparkle of her eyes. The glimmer appeared to leave when her struggles took over. But through the valleys of life, Whitney remained loyal and loving—the words to Dolly Parton's song were just as much Whitney's words to everyone she loved: family and fans. But they are also my words to her.

I will always love you, Whitney.

I know that the weight of fame has fallen off your shoulders, replaced by the peace that passes understanding. I know that heaven's joy is the joy of being in God's presence. But the kid in me—the hopeful idealist in me—sees you lying on one of heaven's couches and rising with the sunshine, your hair all crazy, and then filling the

halls of heaven with song. *Your* song. Not a song you've sung before, but a new song, with words that drip with freedom and peace, words that sizzle with a holy fire—a church song that moves you even closer to the Light of heaven.

That's how I love you, Whitney. I love you in the hope of glory, in the hope that you've returned to the innocence and joy you so desperately sought in this life.

<div align="center">⟡</div>

I think God loves it when we remember and love those who pass away, for it reminds us of the goodness that outweighs all the sadness that too often overwhelms us in this life. I think, just as God listens to Whitney's new song, we ought to not only remember Whitney's songs on earth, but learn from them. Learn from the woman behind the songs—the woman who changed us with her voice.

I was talking to a friend of mine about how fame affected Whitney. He told me to read this quote by C. S. Lewis. You'll pardon its length, but I thought it a fitting passage for such a time as this.

> There are no ordinary people. You have never talked to a mere mortal. . . . It is immortals whom we joke with, work with, marry, snub, and exploit—immortal horrors or everlasting splendours. This does not mean that we are to be perpetually solemn. We must play. But our merriment must be of the kind (and it is, in fact, the merriest kind) which exists between people who have, from the outset, taken each other seriously—no flippancy, no superiority, no presumption.

And our charity must be a real and costly love, with deep feeling for the sins in spite of which we love the sinner—no mere tolerance or indulgence which parodies love as flippancy parodies merriment. Next to the Blessed Sacrament itself, your neighbor is the holiest object presented to your senses.

"There are no ordinary people." I love this. The concept is refreshing in light of our popular mind-set that says there are divisions among us—the wealthy, the poor, the powerful, the powerless, the black, the white. If we can find the humility to step back and see one another not as the culture paints us but as God created us, I think we would treat one another differently. This perspective is the *human* perspective.

At the end of the day, Whitney was a human being—body and soul—just as we are. This commonality should prompt us to take one another seriously, because we'll each face death. And then what? Will it matter if we were rich or famous? Will it matter what we struggled with in this life or what we had victory over? No. It will only matter that we lived and that we loved and that we followed God.

I loved Kevin Costner's comment at the funeral about the debates that will rage in coming years about the best singer of all time and about Whitney's private life and the things she became known for in the tabloids. He cautioned that we remember Bobbi Kristina and Cissy. For they daily will deal with Whitney's death in a way no one else will. In order to heed Kevin's advice, we must view Whitney as our sister—a fellow human who deserves our respect and honor, without flippancy or superiority.

Our love for one another must be costly. What does that mean? I think it means that when the opportunity to judge comes, we approach people with the same amount of love we'd hope they would give us—the kind of love alluded to in "Jesus Loves Me," the kind the Bible speaks of.

What does the Bible tell us about Jesus' love for us? It tells us that the ultimate expression of love is sacrificing yourself for your brother or sister. Jesus said, "Love one another the way I loved you. This is the very best way to love. Put your life on the line for your friends." We can put our life on the line for our friends every day by acting in love.

If we begin treating one another with love, then our actions will spill over into the rest of our culture. The way we interact with one another will be more civil and just. It will be more forgiving. Do we name failure for what it is? Sure. But we don't live in that failure. We help one another toward the goal of restoration.

There is no law against this. There is no law against love. I think this is what Lewis was getting at. Treating one another like the precious immortals we are will bring abundance to life.

I saw the abundant life pour out of Whitney, my forever sister and blessed friend. Now, each time I watch her perform on video, I can see her soul bubbling up into each lyric and ascending into the clouds with each high note. And even though I also saw the light of her abundant life dim at times over our twenty-eight-year friendship, I remember most of all the shimmer and glory that she brought into my life. The shimmer of God's glory that came wrapped up in the person she was. That's the Whitney I knew.

Acknowledgments

Books are interesting animals. They demand much from you but also give plenty back. Behind the words on the pages of this book, there are people who have also given plenty—people I treasure and wish to thank.

I would first like to thank Ron Smith for pushing me and making this book happen. May our friendship continue to be wonderful and strong.

To Jan Miller Rich, for taking good care of me: "Love ya guts!"

To Byron Williamson and Rob Birkhead and the entire team at Worthy Publishing, for leading the way and allowing this book to be one of integrity—one that shows a different side of someone I loved very much.

To Howard Bragman: you're the best, and I'm not speaking of your gift—I'm talking about your heart. Thank you.

To the Houston family: Cissy (Mom), words can't say how much I love you and pray for you; Pat and Gary—my sister and brother—and Donna, Michael, and everyone else in between, I love you all; Bobbi Kristina, you are covered with prayers from all around the world and from the Winans family. We're always there.

And last but not least, "Mr. Man" Tim Willard: this could not have happened without you. I'm honored to share this moment with you and to tell the world that I'm smarter because of you!

BeBe Winans met Whitney Houston twenty-eight years ago, and they quickly developed a family bond. Winans is a groundbreaking inspirational, R&B, and gospel vocalist, writer, and producer whose albums have reached platinum status and who has recorded with such entertainers as Stevie Wonder, Gladys Knight, and many more. He has won six Grammy® Awards, three NAACP Awards, ten Dove Awards, six Stellar Awards, and was awarded a Star on the Hollywood Walk of Fame with sister CeCe Winans. He also launched a syndicated radio show and enjoys acting in both film and theater. Winans' new album honoring our nation's heritage, *America America*, was released by Razor & Tie in June 2012.

Timothy Willard is a popular writer on matters of faith and culture. He is coauthor of *Veneer: Living Deeply in a Surface Society* and has collaborated on ten other books. Tim lives outside of Atlanta, Georgia, with his wife and three children. He would love to connect with you on Twitter (@timothywillard) or at www.timothywillard.com.

WORTHY

P U B L I S H I N G

IF YOU LIKED THIS BOOK . . .

- Tell your friends by going to: www.whitneyhoustonbook.net and clicking "LIKE"

- Share the video book trailer by posting it on your Facebook page

- Log on to facebook.com/worthypublishing page, click "LIKE" and post a comment regarding what you enjoyed about the book

- Tweet "I recommend reading #thewhitneyiknew by@ bebewinans @Worthypub"

- Hashtag: #whitneyiknew

- Subscribe to our newsletter by going to www.worthypublishing.com

WORTHY PUBLISHING
FACEBOOK PAGE

WORTHY PUBLISHING
WEBSITE